Ever After

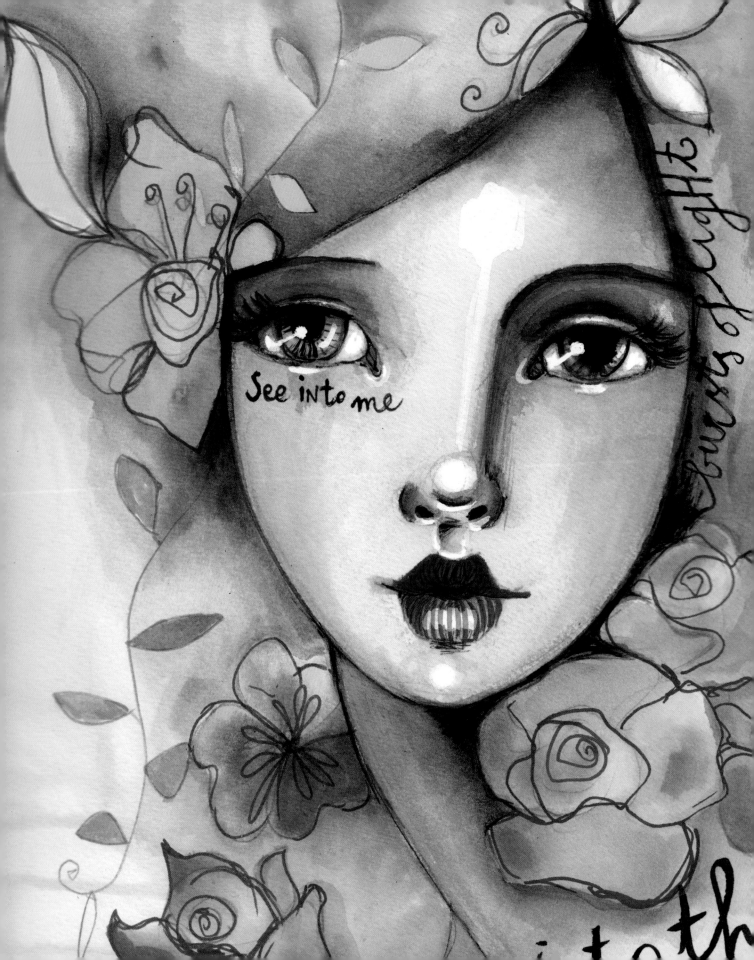

Ever After

Create Fairy Tale–Inspired Mixed-Media Art Projects to Develop Your Personal Artistic Style

TAMARA LAPORTE

QUARRY

Inspiring | Educating | Creating | Entertaining

Brimming with creative inspiration, how-to projects, and useful information to enrich your everyday life, Quarto Knows is a favorite destination for those pursuing their interests and passions. Visit our site and dig deeper with our books into your area of interest: Quarto Creates, Quarto Cooks, Quarto Homes, Quarto Lives, Quarto Drives, Quarto Explores, Quarto Gifts, or Quarto Kids.

First Published in 2019 by Quarry Books, an imprint of The Quarto Group,
100 Cummings Center, Suite 265-D, Beverly, MA 01915, USA.
T (978) 282-9590 F (978) 283-2742 QuartoKnows.com

Quarry Books titles are also available at discount for retail, wholesale, promotional, and bulk purchase. For details, contact the Special Sales Manager by email at specialsales@quarto.com or by mail at The Quarto Group, Attn: Special Sales Manager, 100 Cummings Center, Suite 265-D, Beverly, MA 01915, USA.

10 9 8 7 6 5 4 3 2 1

ISBN: 978-1-63159-665-0

Digital edition published in 2019

eISBN: 978-1-63159-666-7

Library of Congress Cataloging-in-Publication Data is available

Cover and Book Design: Megan Jones Design
Photography: Tamara Laporte except Shutterstock on pages 11, 112, 116 (bottom), and 120 (used in part, image A)

Printed in China

This book is dedicated to my two beautiful children, Dylan and Elliot.

They know me as "The Queen of All Unicorns" and remind me to stay in touch with magic and possibility every day. I love you both to the moon and back.

Contents

Introduction

A Little About Me & Why I Wrote This Book

Hi, I'm Tam, also known as "willowing"—pleasure to meet you!

Since I started running my creative business in 2008, I've taught thousands of awesome folks from all over the world about art and creativity. My own work can be described as "mixed-media folk art" with a focus on "magical realism." Love, mystery, innocence, hope, spirituality, kindness, and self-connection inspire my art, and symbolism and layering play a big part in my creative process. It is my view that the act of creating can be a gateway to healing and personal growth, so my art classes often include an element of self-development. I'm deeply devoted to helping people get in touch with their personal creative fire.

Because I've taught in a *"copy this painting, then learn and develop your style on your own"* format for many years, I've become especially interested in supporting creatives to develop their own artistic styles, to become more familiar with their own voices, and to more deeply embed their personal stories in their creative expressions. Hence, "Ever After," the online art course, was born, and now *Ever After*, this book.

"Follow your bliss and the universe will open doors for you where there were only walls."

—JOSEPH CAMPBELL
(1904–1987)

I hope you love what you find here and that it helps you connect with your authentic voice, both personally and creatively.

Style & Style Development

Throughout my teaching experience, one of the most frequently asked questions—considered somewhat of a "holy grail"—is: *"How do I develop my own style?"*

People love learning from others and are happy to copy them as part of the learning process. Often, though—and sometimes early on in their creative journey—they experience a deep yearning to express their *own* voice. They long to create art that feels more meaningful and true to them, that's imbued with a style that's uniquely their own.

I firmly believe that personal styles emerge when we begin to understand "the story of us." When we reflect on our deepest hopes, dreams, fears, likes, and loves, a truer voice comes forth. And when that voice is expressed through shapes, colors, forms, lines, and characters, our own style can't help but emerge.

Essentially, your creative style is the culmination of the many parts of what it means to be you. It will reflect what you love, your bliss, what you've once done but have moved away from, where your sadness and fears lie, and so forth.

Your style is your personal path toward wholeness and being true to yourself and who you are. Sounds deep? That's because it is! Stay with me on this! All we're talking about here is: How can we tell our own unique story through our art in our own personal way? The good news is that all you need is *yourself*! Your gorgeous, beautiful, amazing self. *You* were the answer all along, you see!

In this book, I demonstrate how we can help our personal style come forth through following our bliss and deepening our understanding of ourselves. Through self-reflection and self-exploration we'll discover and uncover ways to figure out the message that lives inside us and wants to come out and what visual representation of that message makes our hearts sing! I hope you're as excited as I am!

Why Fairy Tales?

Fairy tales, folk stories, myths, and classic fiction are endlessly fascinating when you delve deeply into their history, symbolism, alternative versions, and retellings. As an artist who is developing his or her own voice, it will benefit you to spend time with a story and research its symbolism, intended messages, and various interpretations. The richness of this process can add greatly to one's own imagination and creative growth.

In this book, we share short summaries of the fairy tales, fables, and fictional stories we're working with, but I invite you to further research each one and its various versions. Then, explore your emotional response to gain a richer understanding and to expand your own growth and voice in the process. Make notes about your thoughts and feelings and consider whether you want to add anything to the story or to make any changes for when you create your personal painting.

How To Use This Book

It's fine if you jump back and forth among the various chapters and lessons, but if you do, you may miss some key components of the style development process. So to get the most out of this book, it's best to follow the chapters and lessons in the order in which they're presented.

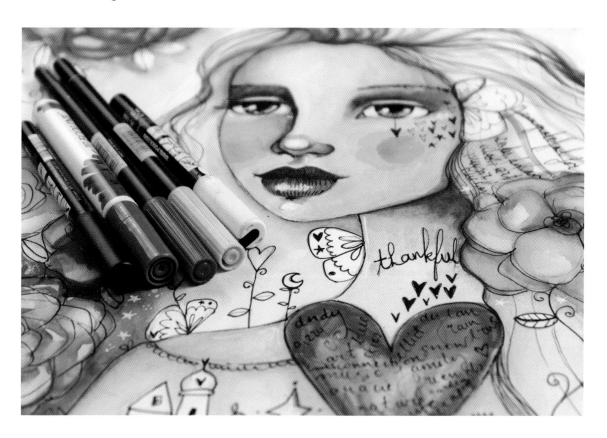

Each chapter focuses on one or more style development themes: "The Story of You," "Inspiration," "Comfort Zones & Productivity," and "Dealing with Challenges & Deepening Your Voice." These themes are then explored through four creative lessons. After you create those lessons as presented, you're invited to complete an additional exploration of that chapter's style development theme to help you infuse your own voice and style into a painting. We've structured the material in this way to help you dive into each aspect of style development as effectively as possible.

Before You Begin

You may want to immediately start bringing more of *you* into the art you're creating! And by all means, if you're creating any art that isn't related to this book: *Go right ahead, groovy creative—I hear you.*

However, if you're going to follow the "program" in this book, to really dig deep and explore yourself, your voice, and your creativity, I invite you to:

1. *Do the lesson pretty much exactly as presented by the teacher.* I realize you might not have all the same supplies, but you should try as much as possible *not* to do your own thing too much. This isn't meant to quell or dim your creative fire, but because I want you to learn new techniques and ideas that may inspire you. Once you've done each lesson in the way it's presented and completed a style development exercise from that chapter, you're then invited to create another painting that's much more in your own voice.

2. *Answer the questions below for each lesson.* Go into a lesson armed with a notebook and a pen so you can make notes about it and about what you're thinking and feeling as you do it, so you can get to know *yourself* better by observing your responses. Notice what you like, dislike, and would do differently, which supplies evoke resistance and which excite you, what shapes,

techniques, and color choices inspire you, what worked for you when you tried it and what you struggled with, what scares you, what challenges you, and what just lights up your soul.

MASTER QUESTIONS LIST

To Be Completed for Each Lesson
- *What inspires me about this lesson?*
- *What techniques and supplies do I really love?*
- *What scares me?*
- *Which shapes/symbols inspire me?*
- *What would I do differently?*
- *What can I take with me for future paintings and adjust so that it's more "me?"*
- *Which colors and color combinations speak to me?*
- *What do I like about how the teacher interpreted the story?*
- *What emotions come up for me?*
- *What am I learning about myself through doing this lesson?*
- *What new things am I learning/ seeing/feeling?*
- *How would I present this story differently/in my own way?*

What You'll Need: Art Supplies

In this book, you'll be introduced to a wide variety of materials and supplies. You don't need to buy them all. Many of the products used in this book can be substituted with other products you may already have or with cheaper alternatives. Initially, work with what you have, and if a particular product really speaks to you, you can always buy it later.

Here's a list of products that have been used in this book, along with possible substitutes, if applicable.

PAPER

- I work on 140 lb (300 g/m²) hot pressed water-color paper. Brand-wise, I usually use Daler-Rowney or Saunders Waterford, but Fabriano, Strathmore, or Canson are also fine. I work either on 9 × 12 inch (23 × 30.5 cm) or 12 × 16 inch (30.5 × 41 cm). Cold pressed is fine, too. (Hot or cold pressed becomes a personal preference over time; cold pressed has a grain, while hot pressed paper is smooth.) Don't go for less than 140 lb (300 g/m²) in weight.
 - » SUBSTITUTES: *I tend not to compromise on paper because wet work is hard on paper. You need good quality paper so it withstands the kind of mixed-media work we do in this book.*
- You can also decide to do these projects in an art journal, on canvas, wood, or board. These substrates will respond slightly differently to your supplies. It's fun to explore and discover how your supplies and substrates interact.

PAINTS & CRAYONS

- Water-soluble crayons such as Caran d'Ache Neocolor II.
 - » SUBSTITUTES: *Any watercolor paints or watercolor pencils. Note: These may not be as vibrant as the crayons.*
- Golden Heavy Body Acrylic Paints.
 - » SUBSTITUTES: *Daler-Rowney, Golden, or Winsor & Newton. Even student-grade paints will be fine if you are just beginning.*
- Golden Fluid Acrylics. These are expensive, so if you want to try them out, buy two or three of your favorite colors to start.
 - » SUBSTITUTES: *Water down heavy body acrylics or add glazing or matte medium to your heavy-bodied acrylics. Some other cheaper brands also do fluid acrylics.*
- Fun but expensive and optional: Golden High Flow Acrylic Paints. Get only a few if you want to try them.
 - » SUBSTITUTES: *Fluid acrylics or watered-down heavy body acrylics can create a similar effect. You can also use acrylic markers (such as Posca markers) to achieve a similar effect. The downside is that the colors vary by brand.*
- Oil or wax crayons or pastels.
- Watercolor paints.

PENCILS

- Colored pencils by Prismacolor or Caran d'Ache Luminance.
- Water-soluble colored pencils by Derwent or STABILO All.
- Graphite pencils, 2B and heavier. I like the Graph Gear 1000 by Pentel, but any pencil will do. Mechanical ones are better for finer detail.

MEDIUMS, PASTES & GESSOS

- Gel medium such as Daler-Rowney Impasto Gel for gluing collage materials. Avoid water-based glues for collage because they will dry out over the years and your collage may peel off.
- White gesso, such as Winsor & Newton, Liquitex, or Golden.
- Transparent or clear gesso such as Liquitex.
- Molding or texture paste such as Golden, Liquitex, or Winsor & Newton.
- Odorless mineral spirit (OMS), heavy.

COLLAGE SUPPLIES

You'll need a variety of patterned scrapbooking papers, magazine pages, book pages, musical scores, and photos. I also often use washi tape as part of my collages.

TOOLS

- Brayer by Speedball.
- Palette knife, optional; you can also use an old plastic card.
- Scissors.
- Ruler.
- Eraser.
- Heat gun or hair dryer, optional; either can be used to accelerate drying times.
- Brushes. I like Pro Arte Acrylix brushes, but any soft-haired firm brushes will do. Avoid brushes with coarse hair; you want soft but firm.

MARKERS & PENS

- POSCA pens or Sharpie Water-Based Paint Markers in black and white, fine-nibbed and thicker nibbed.
- Tombow markers.
 - » SUBSTITUTES: *Any water-soluble ink-based markers like Aqua Markers by Letraset or Sakura markers.*
- Gel pens in metallic colors such as silver and gold.

INKS & SPRAYS

Daler-Rowney FW Artists' Acrylic Ink.

STAMPING & STENCILING SUPPLIES

I use decorative rubber stamps and a selection of stencils. You'll also need waterproof ink pads such as StāzOn.

OTHER SUPPLIES

- Cotton swabs (Q-tips).
- Blending stump.
- Magazines, newspapers, and a printer.
- Crystal chips (for Lesson 6, The Little Mermaid, page 58).
- Old plastic library (or similar) card.
- Brads/paper fasteners.

NOTEBOOK

I recommend getting yourself a notebook specifically for your *Ever After* projects, as a place to write notes in if any ideas, feelings, or needs come up. You can also use it for the writing exercises described in this book.

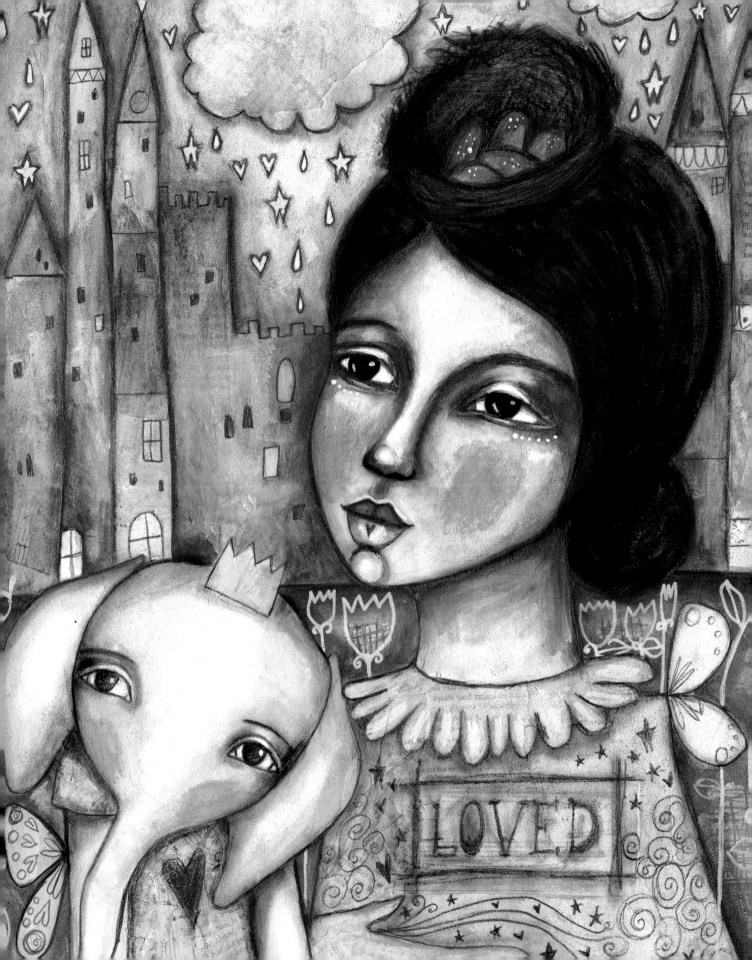

1

The Story of You

FOR YEARS, THE CONCEPT OF STYLE DEVELOPMENT ELUDED ME. When people said they could recognize a Tam painting, I'd think to myself: *Really? Who? How? Why?* That is, until I had an epiphany, now several years ago.

While my friend Gracie and I were listening to a song rich with harmonies and echoes, she remarked, "You really do like layering, don't you?", in my art as well as in music. This made me realize that when something was "layered," whether in my paintings (in which I physically layer paper, paint, and other materials) or in other creative realms—music, lyrics, poetry, or fiction—I enjoyed it the most. That my *enjoyment* of layering was relevant to the concept of my style was a "hallelujah" moment for me.

A few weeks later, as I began sketching the piece shown opposite, I noticed how creating "just a portrait" felt "too boring" to me. I wanted it to have depth and to evoke awe as well as questions and emotions, so people would think about the painting itself and about life, love, mystery, and beauty. The layering theme again!

I also enjoyed placing odd elements in strange places, such as having someone wear a bird's nest as a hat, which also evoked mystery or questioning. And I have a strong need to bring lightness and optimism to my work, so I include whimsical, childlike elements like elephants, bunnies, fawns, birds, clouds, stars, butterfly wings, and hearts. Finally, uplifting words and slogans express my hopefulness about life—that all is okay, in the end.

And once I've achieved all that in one painting, everything falls into place, and the painting feels "perfect," exactly how it should be. It lights me up inside; it's in tune with my soul, with the purest part of me! I now believe this way of creating is in fact "my style!" Hurrah!

Exploring the Personal Side of Style Development

The epiphany I share on the previous page happened many years ago. My style has since evolved, changed, and grown, but I wanted to share that "hallelujah" moment because it's still so important to me and put some real transformation in motion for me. It so fabulously relates the moment I realized that *style development is all about finding and following the thing(s) that make me happy!* It's not about asking: What do other people want to see me do? Or: How can I make art so people will like me? Or: How can I emulate another artist because she's successful? Instead, you need to ask yourself questions like:

- What do I love so much I can't stop doing it?
- What techniques make me light up inside?
- What am I passionately, utterly, irrevocably *in love with* right now?
- What do I keep wanting to create, over and over?
- What feels good to my body, heart, soul, and mind?

It turns out that if you authentically, truly connect with your passion and bliss (plus do some hard work, which we get to in the following chapters), you'll develop a uniquely personal style. And, more often than not, other people are attracted to your work because of that personal spark, that alignment with your passion and bliss. It's like a *magnet.*

Your style is *you*—it's the summary of all your love expressed in shapes, messages, colors, supplies, layers, techniques, symbols, characters, storytelling—it's your "you-ness" represented in your paintings. It's everything that's ever happened to you and influenced you over the years.

You might wonder: *But what if what I like so much is someone* else's *work? Won't it then just look like I'm copying someone else?*

Don't despair if this question comes up for you—it often does when we're in the earlier stages of our creative journey. We're so incredibly impressed by other people's art that it's all we want to be able to make! But once you've "mastered" making art like other people, you'll likely get bored and simply long to be putting more of *you* into your paintings.

So give yourself time to be in love with other people's work. Let that work inspire you to practice your skills, to delve more deeply into the supplies and techniques the artists you admire are using, their color palettes, storytelling, compositions, and so on. Take your time to study others and, soon enough, you'll start to add and change, adjust and adapt, and suddenly your work will look much more like your own.

It's at that point—when you're able to let the work of other artists simply *inspire* you—that you'll be able to make elements and aspects of other artists' work your own.

Exercise: Self-Exploration

In this chapter, before we make any art, I'd like you to do some self-exploration. Getting to know yourself and looking at subject matter, supplies, personal storytelling, artists (and others) who inspire you, color combinations, composition, surfaces, and so on are a very important part of style development. You need to be willing to step back, sink into yourself, and hang out with the inner *you*. Don't be afraid: You are, in fact, pretty awesome. The aim is to get to know your bliss and then—that's right— follow it *all* the way down the rabbit hole!

It's helpful to have a special notebook that you can dedicate to your style development explorations, questions, notes, ideas, sketches, and doodles. This exercise is also supported by an optional "Grounding Into You" meditation that you can access on my website: www.willowing.org (see Resources, page 138).

The questions on the right are designed to make you more aware of experiences, feelings, needs, ideas, joys, and loves in your present and past life that you can possibly bring into your artwork and style. If a question doesn't make sense, try to respond to it intuitively. Some questions are deliberately vague. There are no right or wrong answers—just you, connecting with you. Write down what wants to come forth.

Take some time to really sit with the questions and the answers. Let this exploration marinate. Continue to make notes as you go about your life. You may suddenly notice something new about a habit you have, or a sadness you have, a color that always comes to you, or an animal that you started loving more lately. Bring a mindfulness and a noticing to your life, behavior, heart, and soul. Make mental or physical notes as you go along and then let it all inform your creative process if it calls you.

QUESTIONS: SELF-EXPLORATION

- *Why art? Why do you create?*
- *What are you trying to communicate with your art, if anything?*
- *What sits aching inside of you that wants to come out?*
- *Which artists, musicians, authors, people have influenced you?*
- *What sadness or pain is still unresolved in your life?*
- *What significant thing (or things) happened to you that shaped you and keeps showing up in your life?*
- *What childhood or more recent memories do you delight in?*
- *What did you struggle with as a child?*
- *What shapes, creatures, beings, elements in the world* wow *you?*
- *What, if anything, do you want the viewer of your art to experience or feel?*
- *Which animals are meaningful to you?*
- *What kinds of landscapes and natural scenes draw you in?*
- *What kinds of music and books excite you?*
- *Which colors pull you in? What about textures and shapes?*
- *Draw doodles, shapes, symbols, subjects, and characters that often occur in your art. Write about why they show up and what you like about them.*
- *Which art techniques make your heart sing? Why?*
- *Which art supplies make your fingers itch to make art? Why?*
- *What kinds of stories do you like to tell through your art?*
- *What do you want from your art?*
- *What does your art want from you?*

Follow-up Questions

Now, looking at the answers to the questions above, answer these:
- *How or where do we find you in your art?*
- *What heart and soul part shows up?*
- *What feelings and needs are expressed through your art?*
- *What kind of story telling lives in and through you?*
- *Having worked through the questions, are some parts of you missing in your art?*
- *Which parts do you want to have more representation?*
- *What else did you learn?*
- *What else do you want to take away from this?*

Little Red Riding Hood

"**LITTLE RED RIDING HOOD**" is a European folk tale. While the most widely known version, by French folklorist Charles Perrault (1628–1703), dates from the seventeenth century, its origins can be traced to the tenth century. Those earlier versions differ significantly.

In the classic story, Little Red, a young girl wearing a hooded red cloak, walks through a forest to her grandmother's house, carrying food in a basket. Before she sets out on her journey, her mother tells her to stay on the paths and not stray into the woods. A Wolf lurks in the forest, stalking her with the intention of eating her. He approaches Little Red and convinces her to tell him where she's going. She reveals the reason for her trip and tells him the way to her grandmother's house. The Wolf rushes there, swallows the grandmother whole, and then disguises himself as the grandmother. When Little Red arrives, the Wolf swallows her whole, too.

"Little Red Riding Hood" has a few alternate endings. In one version a huntsman or woodsman arrives, cuts open the Wolf's stomach, and saves Grandma and Little Red; in another, the Wolf is killed by a huntsman before he can eat Little Red and Grandma.

My Thought Process

While reading about and researching "Little Red Riding Hood," I was struck by the contrast between the concept of "innocence" and "the dark." The "preying" element made me feel uneasy. I thought about the messages people were trying to convey through the story and imagined that times must have been hard then, as it speaks of strong warnings and messages to "obey authority" and "keep safe."

What I Wanted to Bring to the Story

As with all my work (and as is very much a part of my style), I wanted to bring light and love to "Little Red Riding Hood." This is related to having endured a challenging childhood. Also, as an adult, I became a practitioner of *Nonviolent Communication*, or NVC, which looks at how we can communicate with more compassion, with the hope of fostering more peace, harmony, and love in the world. NVC plays a very big role in my life and so also shows up in my artwork a lot, in a variety of ways.

Although "Little Red Riding Hood" has many dark elements, my heart longed to transform it into a more compassionate, innocent representation. So I ended up portraying Little Red embracing the Wolf, while including a dark night sky and background to embrace and point toward the darkness in the original story.

The following pages show my process of drawing and painting this artwork. I invite you to follow along before continuing with your own unique interpretation and modifications.

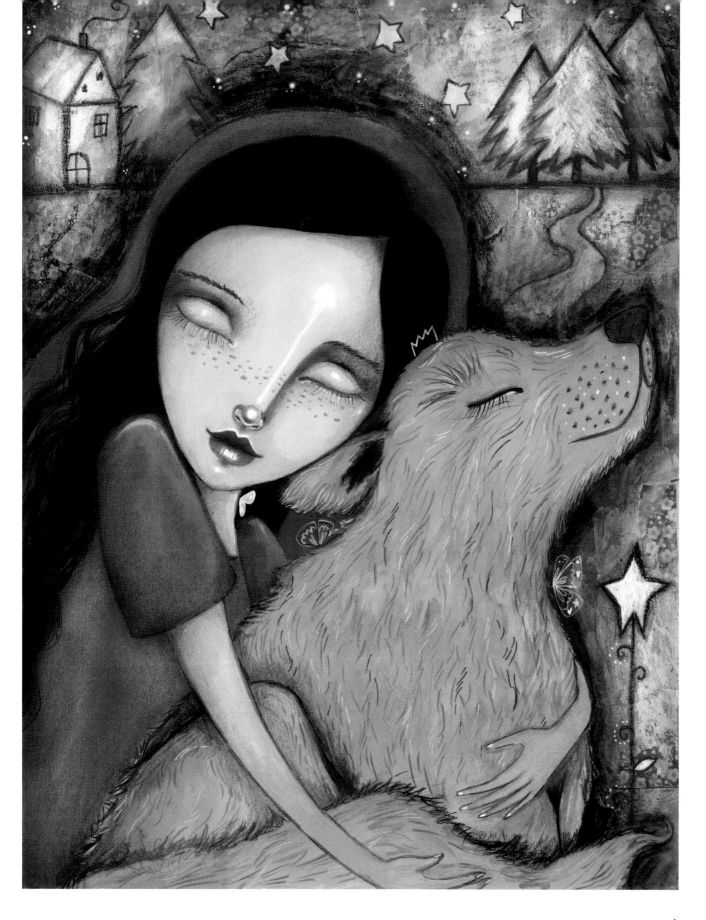

Draw Little Red and the Wolf

Using the finished sketch as a guide, I show step-by-step how to easily re-create this complex image.

1. Start with basic shapes (all gently modified ovals or circles): Little Red's face and shoulder (note the shoulder overlaps the face slightly) and the Wolf's head, muzzle, torso, and rear haunch (**A**).

2. Place guidelines for Little Red's and the Wolf's features (**B**).

3. Sketch in the outlines of major details, here shown in red: Little Red's hair, hood, and clothing and the Wolf's muzzle, chest, and leg (**C**).

4. Add the arms—as the closest element in the foreground, they overlap all the others—along with an initial background and some placeholder embellishments (**D**).

5. Here's the finished sketch (**E**). Note that some of the details will change as you work through and develop the painting.

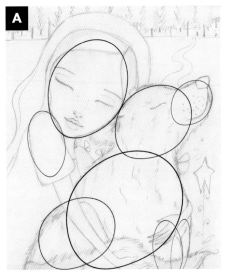

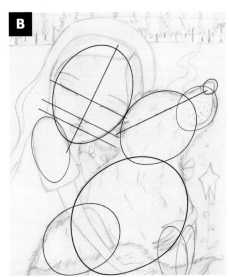

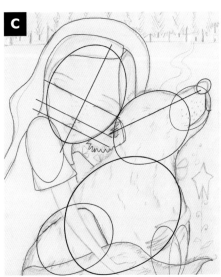

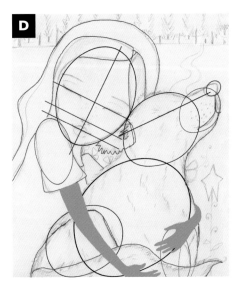

DARKER SKIN TONES

I've painted my version of Little Red as a Caucasian-skinned girl (see opposite). If your Little Red—or any of the other characters featured in the lessons—has darker skin, you could start with an ochre (or light brown) and then build up your darker tones with oranges, reds, blues, and browns.

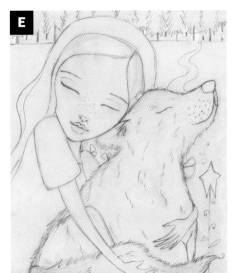

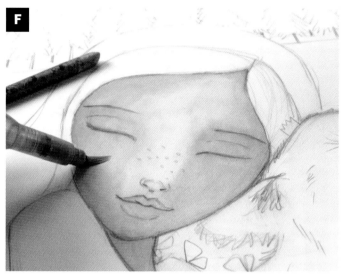

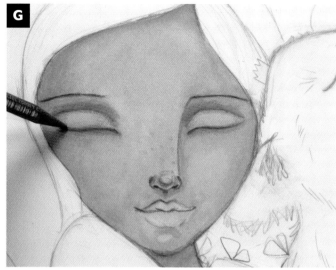

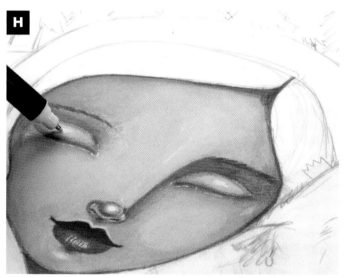

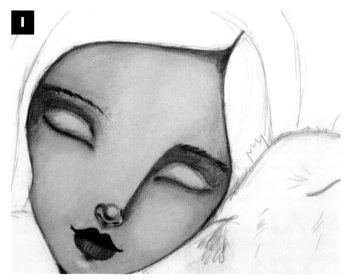

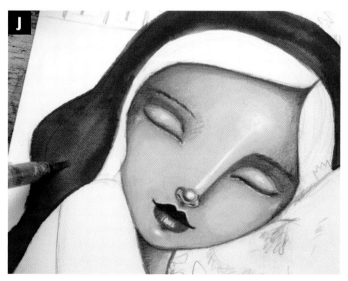

Paint Little Red's Face

1. Start with the basic skin tone. I tend to start my Caucasian-skinned girls with salmon-colored water-soluble crayons or a watercolor paint mixture (**F**).

2. Outline the features with markers (**G**).

3. Add highlights with a white paint pen (**H**).

4. Finish the face by building up darker shading with crayons, colored pencils, and markers (**I**).

5. This step can be done later, but I wanted to set the "color mood" early by adding Little Red's hood (**J**), which helped me choose the rest of the color scheme.

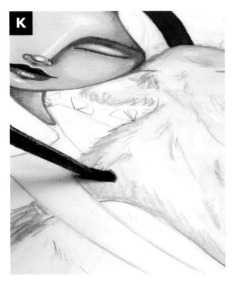

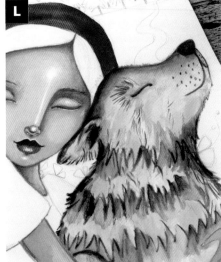

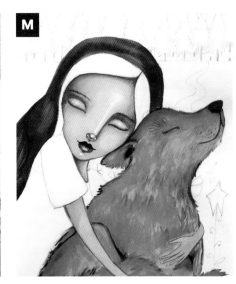

Paint the Wolf

1. To give the Wolf's coat a shaggy look, apply little hair marks with a water-soluble crayon. Activate the crayon marks with a damp brush to leave a subtle layer of color over the entire coat (**K**).

2. Working in horizontal bands across the surface, continue to build up the coat's texture with a variety of deeper blues (**L**).

3. To unify the coat and to soften some of the stronger marks, add a layer of fluid acrylics (**M**). This allows some marks and "shagginess" to show through but won't overwhelm the Wolf's eye.

4. Finish the coat by adding subtler hair strands with colored pencils (**N**).

Paint Little Red's Hair and Dress

I agonized over my color choices for this step, as red isn't one of my favorites. I considered using a color other than red for Little Red's dress, and I also wasn't sure about her hair color. In the end, I decided on black for her hair and red for the dress.

1. Apply red watercolor ink to the rest of the dress (**O**) and black fluid acrylics to complete the hair (**P**).

2. To give the dress dimension, shade it with a colored pencil in deep Bordeaux (**Q**).

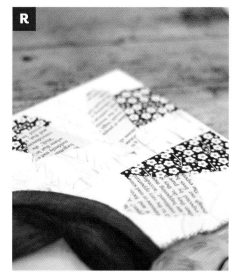

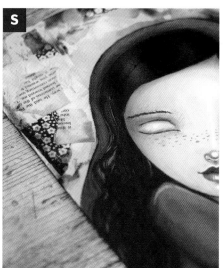

Collage and Embellish the Background

I love adding collage to my backgrounds to create layered texture and depth. Before I begin this step, I often take a photo of the piece to document my initial sketch/drawing.

1. Use gel medium to glue smaller collage materials to the background (**R**). I chose blue tones.

2. At this point, I like to add layers, alternating between opaque and transparent. Start by adding transparent color over the background with a water-soluble crayon and then activate it here and there with a damp brush (**S**).

3. Apply white gesso with a brayer to pull the layers together and mute areas that feel too "loud" (**T**).

Add Finishing Touches

1. Use concentrated patches of the same water-soluble crayon to create balance, harmony, and contrast in the background. So that Little Red and her Wolf friend will stand out clearly, use the same crayon, activated with water, to add an "aura" that will really make them pop off the page (**U**).

2. One of the final steps in my personal process is to add doodles and other imagery that's meaningful to me, especially stars, hearts, houses, crowns, trees, and butterfly wings to the background. For this piece, I used a white paint pen (**V**) and a STABILO All pencil. Use a cotton swab to create a shadow around any doodles drawn with the STABILO All, whose very smudgy line lends itself well to blending/smudging (**W**).

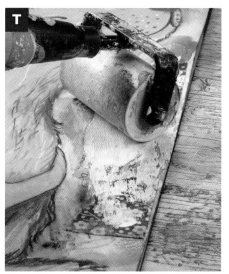

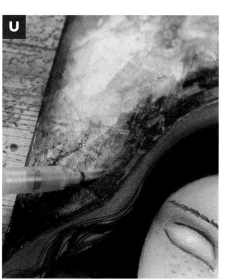

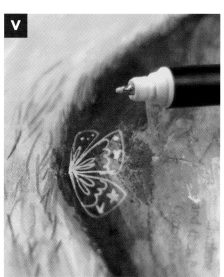

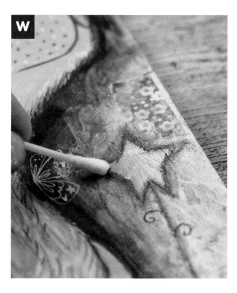

Make It Your Own

Once you've completed your first assignment, I invite you to look back on the questions you answered in the first part of this chapter (page 17). While connecting with your answers, complete the following new assignment:

- Choose several elements from the lesson that you loved and then "take them with you" by adapting and changing them to become more "you," more unique and different from what was presented in the lesson. (See "Ways for Making It Your Own," below, where I share some techniques and examples.)

- Create a new painting based on the same fairy tale, incorporating the elements you loved in an adapted, newer style that feels more like you. Use your imagination, change it up, and bring *you* into it as much as you can. Do you want to focus on a less prominent character in the story? Do you want to bring in different supplies? Do you want to change some of the story? Do you want to "give" something to a character in the story? The options are endless!

- Consider what you want your painting to "say" and how you put *you* into this painting to make it meaningful and personal. Refer to your earlier answers if you need reminders.

HOW TO MAKE IT YOUR OWN

1. *Choose a shape or symbol you really love, one you've seen in an art piece or learned about in an art course.*

2. *Modify, adapt, or transform the shape or symbol by exploring some of these possibilities and the examples of style development shown at right:*

- *enlarging*
- *"quirk-ifying" (making it look wonky, odd, or whimsical)*
- *simplifying*
- *complicating*
- *warping/distorting*
- *enhancing/intensifying*
- *elaborating on*
- *changing its placement in relation to other elements*
- *adding different colors*
- *changing the contrast*
- *adding different patterns*
- *mixing it with other elements that reflect your style*
- *making it meaningful to you by adding personal touches*
- *mixing it with other elements you love, taken from another art class/piece*

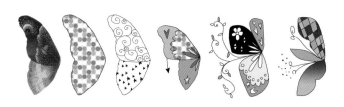

The style evolution of a butterfly wing.

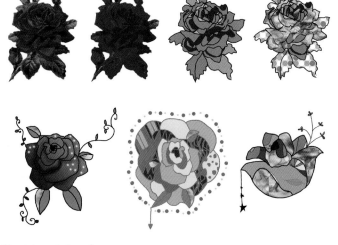

The style evolution of a rose.

The Importance of Repetition

Once you find an element you've really made into your own, repeat it in your work as much as possible (if it makes sense to you and "feels good"). The more you use a specific symbol, painting style, or technique that you've made uniquely yours, it will become a recognizable part of your work. Repeating these approaches to artmaking is a huge part of style development. You'll also naturally want to repeat certain elements because you love creating them so much. This repetition then helps to develop skill and eventually to grow and transform all the elements that make up your style. So keep doing what you're doing! Repeat!

Making Faces

If you've learned how to draw a face from a specific teacher and you want to make it more your own, try playing with the placement, sizes, and shapes of the features and proportions. In addition to the mostly subtle changes shown below, you can continue to learn from other teachers and artists; add, change, and bring certain elements together, the bits that light you up, to create your own style and allow your own voice to come forth.

(A) Original face

(B) Move the eyes down

(C) Enlarge the mouth

(D) Enlarge the eyes

(E) Enlarge the nose

(F) Change eyebrow, eye, and eyelid shapes

(G) Change the shapes of the nose and mouth; move both down

(H) Change the face shape (shown narrower here)

(I) Change the shapes of the face, eyes, nose, and mouth

(J) Exaggerate all features

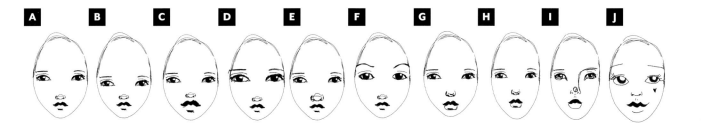

Bambi: A Life in the Woods

Guest Teacher Micki Wilde

Meet Micki Wilde

I don't know if she knows it, but I'm one of Micki's biggest fans. I own several pieces of her original art, and pretty much each painting she shares delights me. I love the sense of whimsy and playful wonder in her work. For this lesson, she works with the story of Bambi: A Life in the Woods.

BAMBI: A LIFE IN THE WOODS is a story based on the life of a deer from birth through to adulthood. It focuses on the life lessons he must learn to survive, including the dangers humans pose to woodland animals.

There are tales of friendship, love, and loss all within this classic story. Originally published in Austria in 1923 and written by Felix Salten (1869–1945), the book has been translated and published in many languages around the world.

Young Bambi at first is kept by his mother's side, being protected by her until he is old enough to go to the Meadow, where all the other deer gather and meet. He meets many other animal characters before being allowed to go to the Meadow, where he eventually meets his cousins Gobo and Faline, along with his Aunt Ena and many other deer. The young cousins share stories about the woods and other creatures they have met and discuss dangers and scary stories they have heard from other deer.

The story takes you through how harsh winter in the woods can be for the wildlife and even includes a conversation between two leaves on an old oak tree about how winter affects them, too.

Later on in the story tragedy occurs, when Bambi's mother is killed by a hunter; Bambi's emotions, from the first shock to the loneliness of grief and loss, are recounted. Eventually, Bambi is taken in and looked after by Nettla, an old doe who no longer has children of her own.

When spring finally reappears, Bambi soon finds a mate in his cousin Faline. They spend many happy times together and share lots of stories until it's time for Bambi to have time on his own and learn how to be an older deer in the woods.

My Thought Process

Reading this story again after many years brought back to my mind the harshness of life in the woods for animals, especially over the winter months. The constant threat by humans to the peaceful woodland animals made me feel an unease and a sense of guilt as a human.

As the story goes on, though, I got a sense of "it's all part of the life cycle"—animals and humans alike just trying to survive—and to do what they think is right in order to do just that.

As I finished the story, I pondered many different thoughts and what-ifs. After reading this story again, I know my own precious time spent walking in the woods will be done with a new appreciation for the hustle and bustle of the animal life that we humans don't always see.

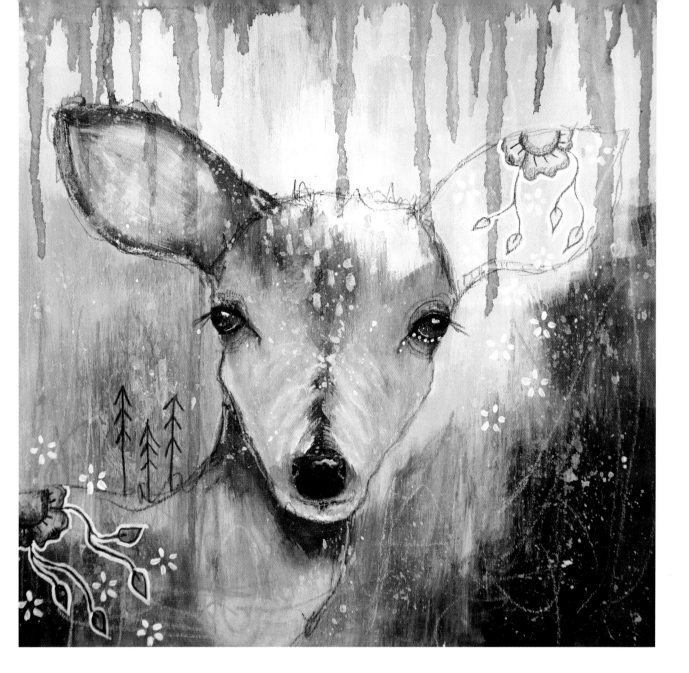

What I Wanted to Bring to the Story

My personal artworks are done in a light-hearted, whimsical manner, and I like to embrace a feeling of mystery and enchantment within my work as well.

I painted a young Bambi to try and capture that part of the story where everything is intriguing and filled with wonder. My favorite place to be is the woods, and I love the way the light is captured and seems to dance through the trees. I chose my background colors to depict the ever-changing colors that stream through, making the whole place feel magical and mysterious. I also included my own personal flower symbols that I use in all my paintings to represent my presence within this story and my own respect and love for nature.

I hope to draw you into my magical, whimsical world, and I invite you to follow along with the steps below using your own interpretations, modifications, and wild imaginings.

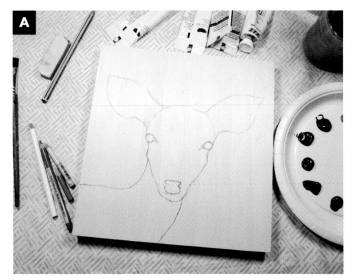

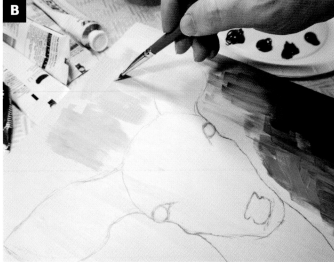

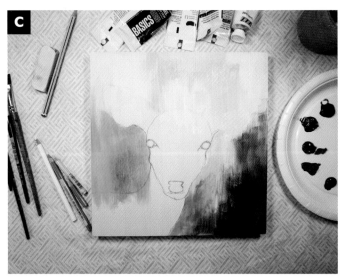

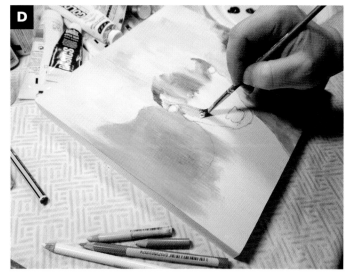

Draw Bambi

Draw the deer on the surface. I used a wood panel for my painting, but you can use any substrate you prefer (**A**).

Paint the Background

1. Paint your chosen color palette onto the background (**B**).

2. Don't be afraid to brush some of the background colors onto your deer sketch (**C**).

3. Add a brush-mix of brown/beige shades to the deer's face and head area (**D**).

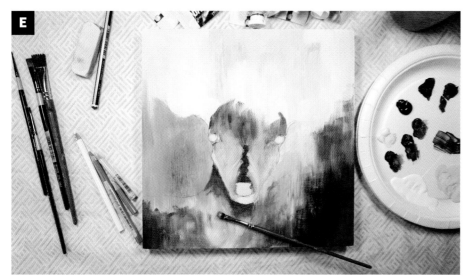

4. With some added shading around the nose and neck, the deer will start to "pop" a bit more from the background (**E**).

Start to Add Details

1. Adding details to the eyes and nose really makes this painting come to life (**F**).

2. Now that the main facial features are done, this deer looks like he's ready for fun (**G**)!

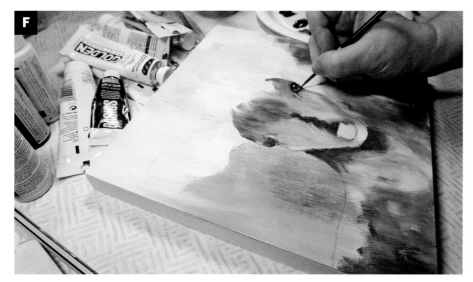

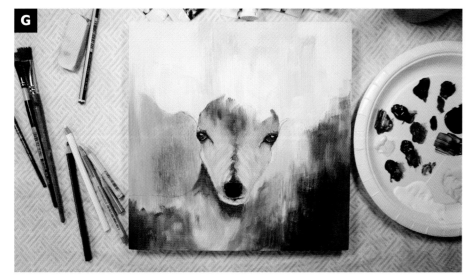

Have Some Fun with It

1. Paint one of the ears; let dry. Add interest to the top of the painting with some watered-down black paint, letting some drips flow through the deer's ears and over his head (**H**).

2. Use a black colored pencil to create some loose scribbles around the deer's outline (**I**).

3. Flick some white watered-down paint onto the painting to create a sense of spontaneity (**J**).

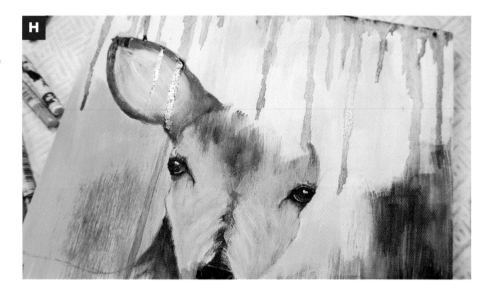

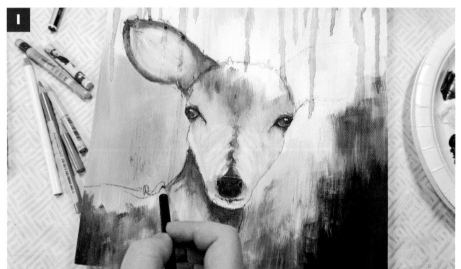

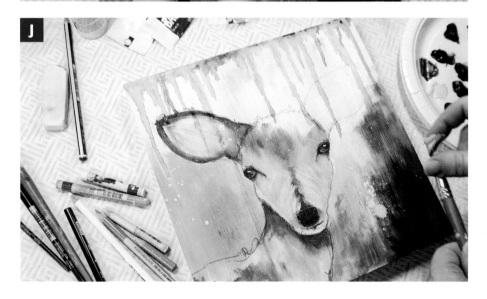

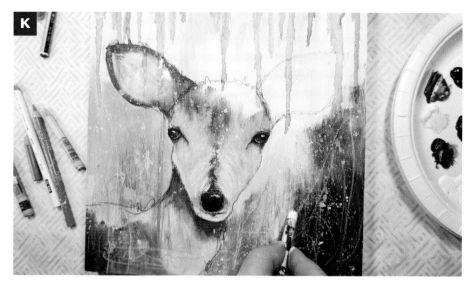

4. Once the white spatter has dried, add some scribbles with white and pink watersoluble pencils or watercolor crayons (**K**).

Add Finishing Touches

1. Here, I used my personal flower symbol to represent myself within this painting. Try using some marks and symbols of your own to help tell your personal story. Then add small details like eyelashes with black colored pencil (**L**).

2. As a final touch, use black colored pencil to add more symbols representing the woods where Bambi lived (**M**). The finished Bambi painting is full of innocent curiosity, wonder, and love.

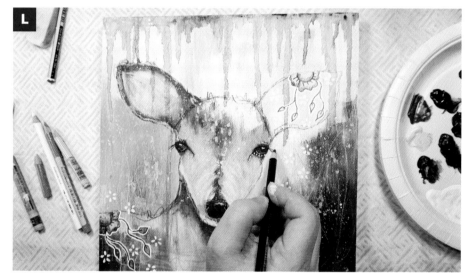

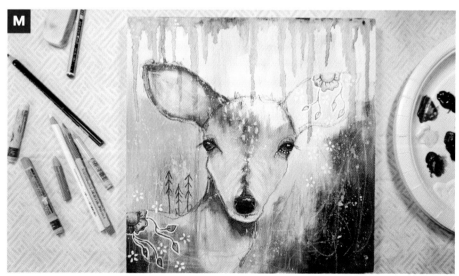

Alice's Adventures in Wonderland

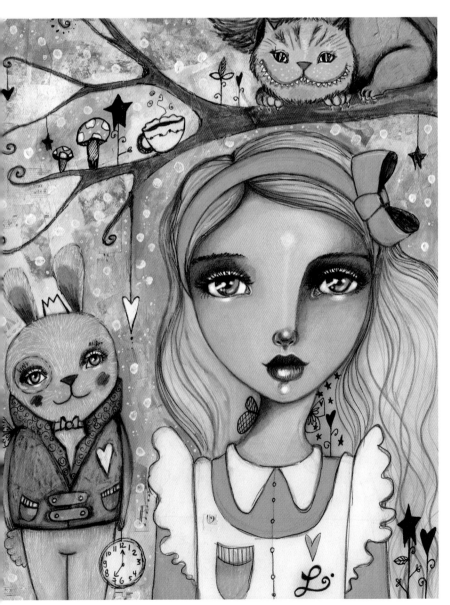

ALICE'S ADVENTURES IN WONDERLAND is a novel written in 1865 by English author Charles Lutwidge Dodgson (1832–1898) under the pseudonym Lewis Carroll. It tells the story of a girl named Alice who falls through a rabbit hole into a fantasy world inhabited by strange anthropomorphic characters. Peculiar and unusual experiences happen to her while in this magical place. The story has been highly influential in both literature and popular culture.

My Thought Process

The biggest thing that struck me when looking at this story was how overwhelming and unsettling the series of peculiar events would likely be if they were to happen to someone in "real life." Alice goes from one chaotic, strange experience to another. Though I don't think the story was written as a symbolism for the "chaos of life," I couldn't help but think that each experience could represent or symbolize the many overwhelming stages and chaotic experiences we all go through. In my personal spiritual practices, I've been working with *surrendering to what is* and *allowing life to be*, instead of *resisting what is*. To me, this story spoke to the concept of *having to let go of control*, which is something I've personally struggled with. As I was reading the story, I was both anxious and impressed by Alice's resilience as she went through the odd experiences that simply kept happening to her.

What I Wanted to Bring to the Story

This story touched a deeply spiritual nerve for me. I'm often faced with my own resistance to certain experiences, and I know that this resistance and rigidity doesn't make the experiences any easier. I constantly work on allowing even painful or crazy experiences to "flow through me" or for me to "go with the flow" of life instead of trying to "control it." The story of Alice reminds me of this challenge and the spiritual practice that goes with it. I imagined that the best way for Alice to get through all her experiences is to be strong and allow life to simply take her on this journey. You may have heard people say, "*What you resist, persists; what you allow, transforms.*" Resistance seems to create more of what you don't want, so a willingness and ability to surrender to the flow of life (as crazy and peculiar as it might be) seems needed and helpful.

That's why I decided to create a painting of Alice with some of the main characters of the story surrounded by a slightly chaotic yet brightly colored background representing the myriad odd experiences Alice went through (and on another level, we all go through in life). I also wanted her to be supported by a symbol that would help her and reemphasize the helpful strategy to *surrender to the flow of life*. So, I added a specific symbol to her top (see sidebar below).

PERSONAL SYMBOLOGY

After spending quite some time researching symbols and their meanings and not being able to find one for "surrender," I suddenly felt excited about the idea of making my own symbols! It's quite a wonderful thing to make your own symbols that can become part of your unique voice and creative style. The more you use those personal symbols, the more you'll be creating a recognizable style. I made my own by following this process:

1. *Have a piece of paper ready to draw on. Hold a pen or pencil in your nondominant hand.*

2. *Focus on the quality and energy of the word you want to create a symbol for. Close your eyes, breathe in, and become still.*

3. *Once you feel you've connected sufficiently with the energy of the word, start drawing intuitively, possibly even with your eyes closed, with your nondominant hand. Try not to use your thinking mind too much, just allow your hand to flow. This way, you'll bypass the left brain and access the more intuitive right brain.*

4. *A symbol or image will appear. It may look scribbly, but that's okay.*

5. *Use your dominant hand to refine and stylize your intuitive "scribble" creation.*

A series of sacred personal symbols I created using the method described at left.

SURRENDER TO/FLOW

GROUND & CENTER

STEP BACK/ SLOW DOWN

STRENGTH/ PROTECTION/POWER

ACCEPTANCE

GROWTH/EXPANSION

VITALITY/LIFE FORCE

COMPASSION/EMPATHY

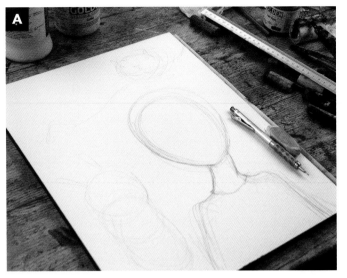

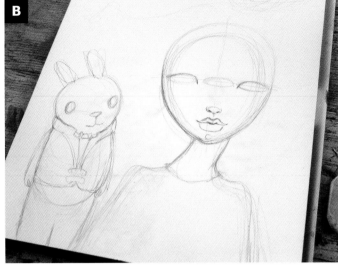

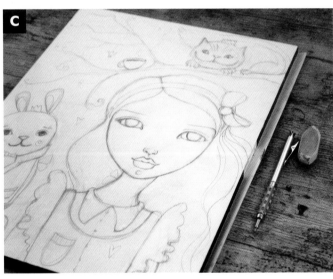

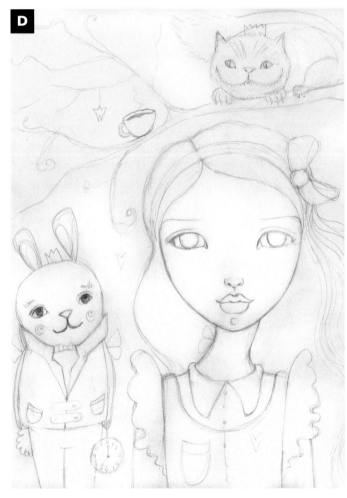

Sketch the Design

1. Begin by lightly sketching in the Alice character, which will take up the majority of the piece (**A**).

2. Add the White Rabbit alongside her. He should appear smaller because he's in the background (**B**).

3. Refine the details: Add the features, clothing, and background (including the Cheshire Cat!) (**C**).

4. Here's the completed sketch (**D**).

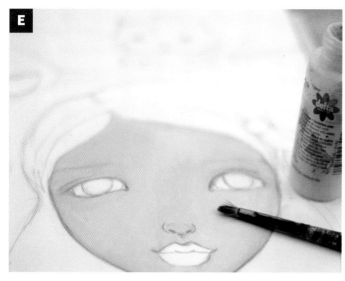

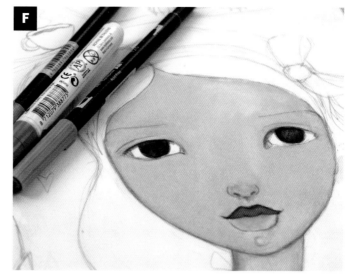

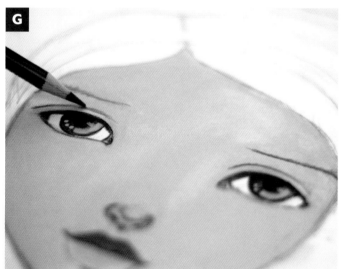

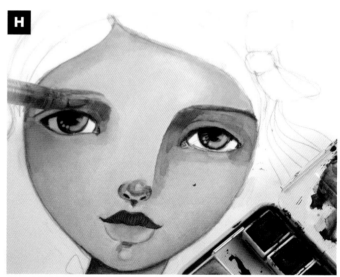

Paint Alice's Face & Features

1. I usually start my Caucasian-skinned girls with a salmon skin tone with water-soluble crayons or watercolor paints (**E**). (See page 20 for advice on how to start darker skin tones.)

2. I build up darker shading and initiate features with crayons, colored pencils, markers, and watercolor paints (**F, G & H**).

3. Then I add highlights with a white paint pen (**I**).

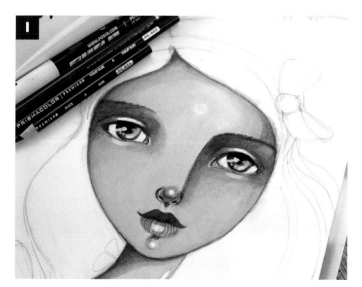

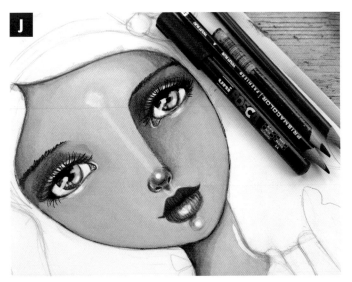

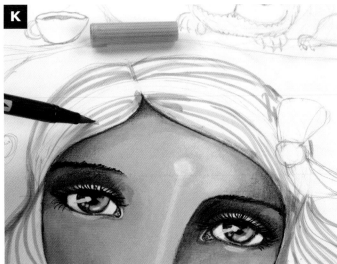

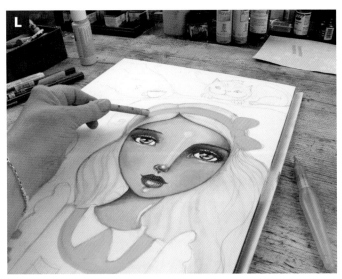

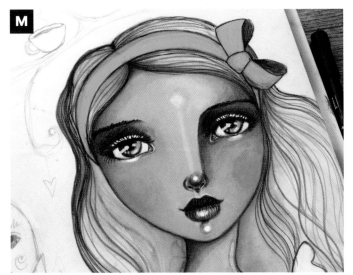

Refine Alice's Features; Add Her Hair & Clothing

1. I used water-soluble markers to add details to Alice's eyes and mouth (**J**).

2. With a Tombow marker, fill in Alice's hair with strands of light golden yellow. Add delicate shading in reds and pinks to Alice's cheeks and temples (**K**).

3. Use a water-soluble crayon to add the distinctive light blue to Alice's clothes and hair band (**L**).

4. Outline all the elements you've filled in with a black fineline marker. Add lowlights to Alice's hair with colored pencils in a range of browns (**M**).

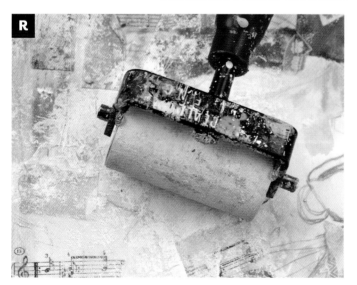

Create the Background

1. For my backgrounds, I like to work in layers. First, adhere pieces of collage (**N & O**).

2. For the second layer, add water-soluble crayons in a variety of colors that fit the scheme (**P & Q**).

3. To bring unity and cohesion to the background, apply a layer of gesso with a brayer. The brayer leaves a textured/grungy effect that adds interest and depth (**R**).

Add the Other Characters

Add basic first layers with some collage (so the style stays in line with the background) and then add details and shading with colored pencils, paint, and markers (**S, T, U, V & W**).

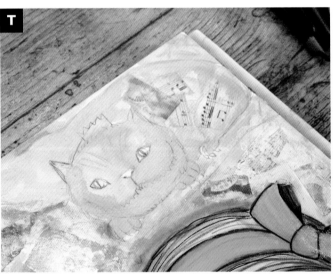

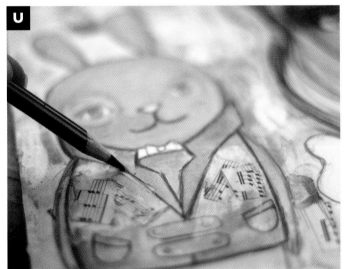

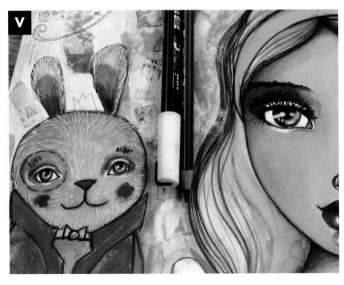

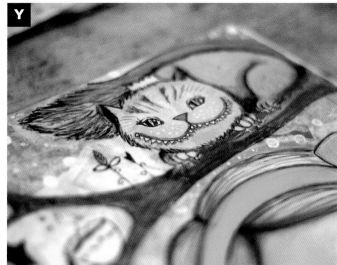

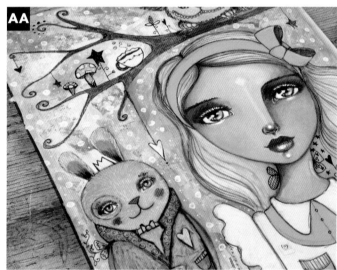

Bring It All Together

1. Tidy up other elements in the background, paying attention to contrast, line work, and detail. To finish, add white dots with a cotton swab. This brings "sparkle" and "magic" to the painting which, to me, emphasizes the magic of the *Alice's Adventures in Wonderland* story (**X, Y, Z & AA**).

2. As the very final step, I add my self-designed symbol for the word "surrender" to her top (**BB**).

Rapunzel

Guest Teacher Annie Hamman

Meet
Annie Hamman

Annie's art immediately pulls me in and invokes a sense of depth and wonder. I love how her art tells stories and asks the viewer to contemplate more than just what they see. Her art is reflective and beautiful. In this lesson, she works with the story of "Rapunzel."

LIKE MOST CHILDREN, I HAD HEARD THE STORY of "Rapunzel" but never thought much of it until I had a daughter and had to read it to her myself. I still remember my thoughts after coming in touch with the story after so many years: *"What a horrific tale of child abuse."* It disturbed me deeply, and it kept retelling itself in my head for a while. A man steals some lettuce for his pregnant wife from a witch's garden. After the witch catches him, he agrees to give his newborn daughter to her. I thought, *"What is wrong with him?!"*, flabbergasted for days after. But of course that wasn't the point of the story.

The witch takes the newborn child deep into the woods and locks her in a tall tower with no door and one window at the top. Rapunzel grows up there, in the dark of a tiny room. Her only companion is the visiting witch, who climbs up Rapunzel's long hair like a ladder. I kept thinking and pondering, *"Why didn't she cut off her own hair, climb down on it, and escape?"* That, in a way, was the point of the story. Escape.

Rapunzel prefers to do it with the help of a prince who stumbles upon the tower by chance and climbs up Rapunzel's hair. Since the story was written in the olden days—in 1790 by Friedrich Schulz (1762–1798)—the notion that a woman could never accomplish escaping her fate on her own is understandable. There had to be a rescuer, and he had to be handsome. The furious witch who catches them before they manage to escape cuts off Rapunzel's hair and kicks her out and then throws the prince

out of the tower, blinding him. The prince wanders in the desert until Rapunzel finds him, magically heals his eyes, and they live happily ever after.

My Thought Process

As I processed the story more deeply while creating this artwork, I watched it unfold before my subconscious and I saw a fear in Rapunzel's mind. I felt it. The fear of a young woman, who knows nothing of an outside world, who longs to escape, but the fear of the unknown—and of not making it on her own—is stronger.

This fear is known to so many of us—especially women and especially dependent women. Yes, she knows she could cut her own hair and just climb down. But would she do it? Would I do it?

What I Wanted to Bring to the Story

As I sat there, in her place, in the dark of a tiny room, the small room I was in suddenly became vast, deep, and full of scary shadows. A dark river of the unknown flew between me and a window. More than one possibility of escape crossed my mind, none of which seemed safe and easy. Do I have enough courage for the staircase? Do I have enough strength for the ladder? But then, there was that bright light of hope coming from the window and a stream of fresh air. There was hope to love and be loved, out there, in the freedom of a sunny world.

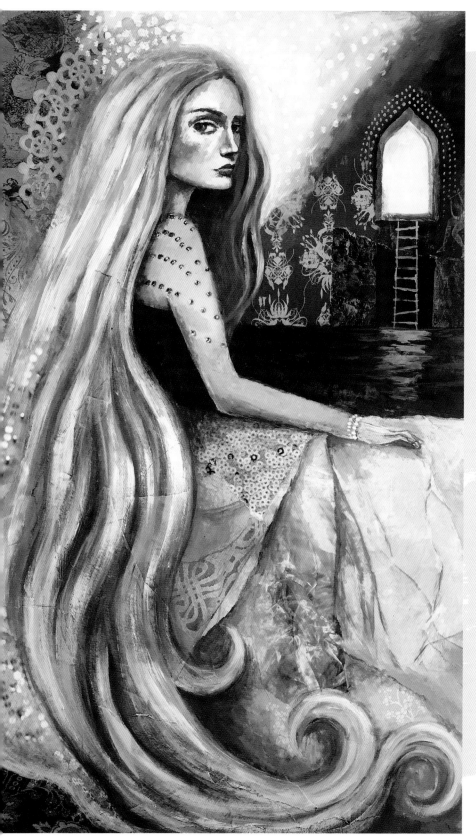

ANNIE'S TIPS FOR DEVELOPING YOUR OWN STYLE

Dear artist, before you embark on a journey of Rapunzel, I'd like to equip you with my three most helpful tips, the most important points that I teach in painting soulful story art:

- *Any color combinations will work.* *Believe it or not, I learned this by experimenting with random color combinations with every single artwork in my life, and I've created many. Just pick any yellow, any blue, any red, plus a couple more, and dive in! Heck, you don't even need primaries; pick only two colors—yellow and purple, or blue and orange—and it'll still work.*

- *Push through the ugly stage.* *Somewhere in the middle of creating an artwork, every artist, from beginner to experienced, always faces a stage where things just don't look good; it feels like there's no way you'll pull it all together. Hang in there and keep painting. It will all come through beautifully.*

- *Paint until you're happy. Somewhere toward the end, your artwork will seem complete, but not quite. Sometimes—or often—we feel not completely satisfied with it. This isn't a time to give up. Just put another layer on, and you'll see—the fairy tale magic will happen!*

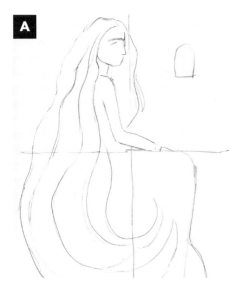

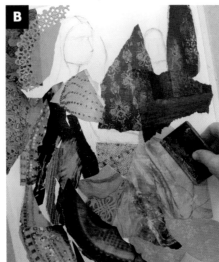

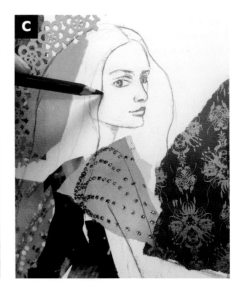

Sketch & Collage

1. Using a reference photo(s), begin by drawing the approximate shape of a figure of a seated Rapunzel on paper with an HB pencil. Take your time in working out your composition, making sure you're happy with the position on the figure before proceeding to next step. There's no need for a detailed face just yet (**A**).

2. Select your collage pieces, torn from magazines, and arrange them around but not on Rapunzel's face. (It's frustrating to try to paint a small face over a magazine image.) Apply acrylic gel medium with a large wide brush to the paper, stick a collage piece on, and then smooth it with a discarded plastic credit card to avoid bubbles. Repeat until all the pieces are in place (**B**).

3. Draw Rapunzel's face in detail, along with the rest of her figure. Divide the oval of her face into three equal parts: The bottom part is from her chin to the tip of her nose; the middle part is from the tip of her nose to her eyebrows; and the top part is from her eyebrows to her hairline (**C**).

Prepare Your Color Palette

Don't stress or fear this step. Your colors don't have to be the same as mine. Whatever you mix will work. Just take care to mix a skin tone that you're happy with. Create lighter tints of all the mixtures by adding white (**D**). I used acrylic paints so I could work in layers.

1. Raw umber

2. Quinacridone burned orange + phthalo blue

3. Phthalo blue + primary yellow + a touch of pyrrole red deep to reduce intensity

4. Blue + a touch of orange to tone it down

5. Orange + pyrrole red

6. Mixture 5 + a touch of blue

7. Skin tone mixture: 2 parts yellow + 1 part red + a touch of blue (compare it to your own skin tone as you mix and adjust as needed)

8. Skin tone mixture + a touch more blue and yellow

9. Pyrrole red (darken with a touch of orange or blue; lighten with white)

10. Orange + a bit of yellow + a touch of blue to subdue intensity

11. Yellow + a bit of orange

12. Orange + a bit of yellow (same as Mixture 10, but without blue)

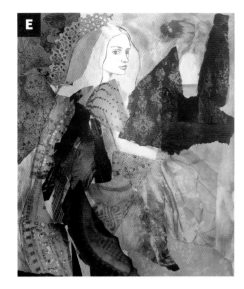

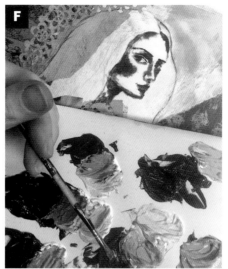

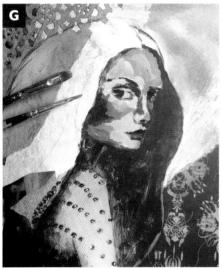

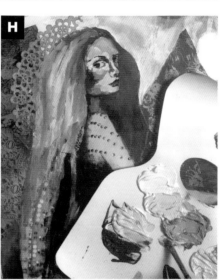

Paint Rapunzel's Face; Begin Her Hair

The success of your face painting will depend on how closely you observe and translate light and shadows in your reference image. When I refer to *value*, I mean a particular color's darkness or lightness.

1. Use a slightly damp sponge to apply a wash of greenish-golden brown ink to the collage to give it a uniform look. Keep a damp clean cloth at hand to quickly wipe off excess in case the wash is too dark on some areas (**E**).

2. Take the darkest skin tone and apply it to all the shadow areas on Rapunzel's face. It doesn't need to be precise, and it's okay if you overpaint some lighter areas. This establishes a bone structure under our muscles and skin and is an important foundation in layering with acrylics (**F**). Let dry.

3. Alternating among middle-value yellowing, pinkish, and greenish hues, apply a second layer of skin tones around Rapunzel's face and neck, mainly next to the darkest tones, leaving the lightest areas untouched. To do this, I hold two brushes in my hand at the same time—a small filbert and a tiny bright for details—alternating between them. The skin at this point will look rather dark and dull, and the face will go through an ugly stage. Don't worry, it's normal. I also added some dark brown underlayer to the right side of my Rapunzel's hair to indicate a cast shadow (**G**).

4. Apply some vibrant yellows of darker and middle values and in long thick stripes on the top half of Rapunzel's hair. Add a bit of darker brown here and there for contrast (**H**).

WORKING WITH REFERENCE PHOTOS

If you're unable to paint from your imagination—as I was for many years—just gather as many reference images as you can to support your story. Look online for photos of a seated girl, river, window, halo, dress, hair, hand, and other details you would like to add. You'll succeed more in creating the impression of a river in just a few strokes of a brush if you have good reference before your eyes. Trying to remember what a river looks like has never worked for me.

5. Apply a third layer to the face, alternating between middle and light values, moving color around and blending the edges of neighboring values. The face will become lighter and start looking a bit better. If not, just put another layer on it—there's no limit to layering with acrylics (**I**).

6. Compare the darks and lights in your painting to your reference image. Reapply the darkest darks where you may have lost them (usually inside the nostrils, the line separating the lips, the pupils and eyelashes, next to the hairline, and under the chin). Add pure white reflections and highlights to Rapunzel's eye, above her brows, to the tip of her nose, above her top lip, to the chin, and on top of the eyelid. Good contrast will add to the success of your work (**J**).

Add Symbols to the Background

1. Work within a corner of the collage to share your take on the story with symbols. Working in the upper-right corner, I started by blending an area of light and dark to add contrast and drama. See if any of the shapes in your collage remind you of something. Go with the flow of your collage, accentuate some shapes, overpaint some, and leave some as they are. Think about what Rapunzel's life represents to you and then add some symbols related to that. These are the words that came to me: window, darkness and light, halo, ladder, chains, little girl, witch, and candle (**K**).

2. I envisioned a dark area as a river, so I added white reflections to it. Other shapes reminded me of rocks and stairs, so I accentuated that and added a ladder beneath the window, signifying that every situation has more than just one way to escape (**L**). If you absolutely can't see anything in your background, either overpaint an area of your collage and add a room interior or turn it into an abstract background with shapes and patterns (you can use stencils to help with that).

Develop and Finish Rapunzel's Hair

1. Take your time on Rapunzel's hair, as it's her most recognizable asset. I built her hair using about four layers. In the first layer, I used white and brown water-soluble pencils to sketch long, curly streaks and then painted dark brown lines between these streaks. These lines were darker initially and then overpainted with lighter layers in the following steps (**M**).

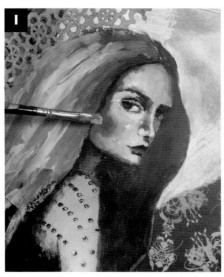
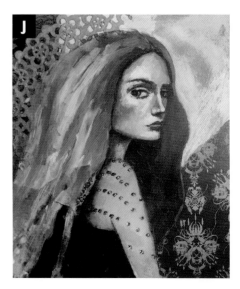
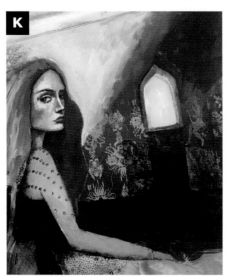

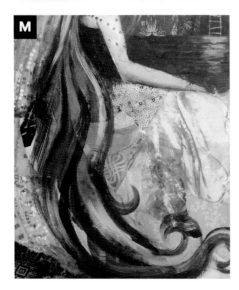

2. Don't forget the areas around the hair. I extended some collage areas by imitating patterns and matching colors and overpainted others that I felt weren't working (**N**).

3. Within the hair, apply some cream/light yellow streaks next to and over the brown ones. Let dry and then paint over the white streaks with pure yellow or yellow mixed with a tiny bit of red to create a translucent glow and give the hair a golden appearance (**O**). (Note that painting yellow over darker streaks will consume the yellow and make it look dull.)

4. Put lighter browns, yellows, and whites in the hair, blending some streaks together to eradicate harsh contrasts. Use a good reference image for long hair to evaluate the darkest darks. I created soft transitions between streaks by overlapping multiple colors and adding highlights to some areas (**P**).

Finish the Dress

1. Use medium-value browns to create shadows on Rapunzel's dress cast by her hair (**Q**).

2. Follow lines within the collage to create folds and creases, maybe an apron or lacy petticoat (**R**).

3. If areas within the dress aren't working, overpaint them with colors that match the adjacent area (**S**).

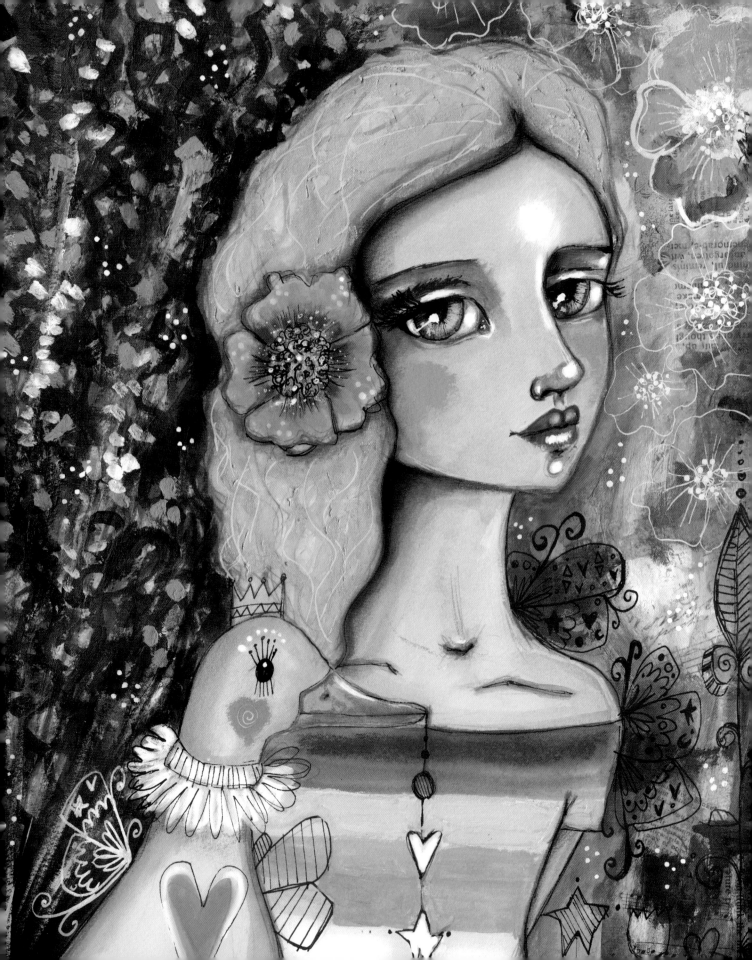

2

Inspiration:
How to Find It, How to Use It

Now that we've delved deeply into *the story of you* and how to use that information to support your style development, I want to look at how we can find and use other inspiration to help further develop our own voice.

People have always wanted to understand the concept of inspiration, what it means and how to get it. The word itself comes from the Latin *inspirare*, which means "to breathe into." According to Merriam-Webster.com, inspiration is "a divine influence or action on a person to qualify him or her to receive and communicate sacred revelation," as well as "the action or power of moving the intellect or emotions."

Historically, interpretations of what "inspiration" is and where it comes from have varied widely. Some believed inspiration was divinely generated or bestowed upon by the Gods and Muses. Others, like the Swiss psychiatrist Carl Jung (1875–1961), suggested that inspiration came from encoded archetypes in the mind.

The mysteries of how we're inspired and what it means to be inspired have been a topic of study and conversation for as long as humans have been thinkers. Artists as well as philosophers, business people, scientists, and everyone else have all wanted and needed to be inspired and find innovative ideas to further their work.

For artists, inspiration often seems to be the "juice" of *motivation*. It's *the* thing that can lead to satisfying new creative ideas. Developing a discerning eye and learning how to open yourself up to innovation and inspiration is also essential when you're learning to develop your own style. It's the bit that moves us from solely copying/learning from others to helping us bring in more and new ideas of *our* own.

In my experience, new and innovative ideas are often simply connections made between other ideas, nudges, or concepts. A new idea is often a mix/jumble/hybrid of a lot of little other ideas and inspiration.

Staying Open

The beginning of a new idea can sit within the mind dormant for quite some time, waiting for another inspired concept to combine with! The more we seek out inspiration and experiences, the quicker new ideas may arise.

Staying open and unhindered by judgments and expectations can allow the mind to more freely and easily make connections between ideas and experiences that lead to new and inspired ideas.

In the previous chapter, we worked on *making elements you were taught in classes or concepts you've seen in other people's work your own*. In this chapter, we're going to broaden and widen where we might find inspiration *out there* and look at how we can use what we see, hear, feel, and smell all around us and bring it into our art so that we can further our creative style.

Exercise: Incorporating Inspiration into Your Art Practice

Inspiration is all around us. New ideas, concepts, shapes, and colors can be found in the tiniest things, like a ladybird or a leaf, or in larger, more complex and obvious places, like museums, movies, and books. We can also derive inspiration from more abstract experiences like dreams, emotions, memories, or music.

"Inspiration exists, but it has to find us working."

—PABLO PICASSO (1881–1973)

To be open to inspiration, one needs to take on a particular mindset or attitude and make an active decision to *pay attention* to all that's around us in the world. As an artist, if you go through life not really noticing the world around you and within you, it's harder to find inspiration and move forward. So a big part of finding inspiration is becoming more aware of your inner and outer world and really being *open* to it and *actively* looking for it too.

This chapter is supported by an "Opening Up to Inspiration" meditation that you can access on my website (see Resources). The meditation is an optional tool if you're interested in it.

Here are some more ideas on mindset and "attitude" to help you be more open to inspiration:

- If you don't already, start actively and mindfully *seeing* things or, better yet, **noticing the world** around you more acutely through *all* your senses. Pay attention to all that you see, feel, hear, and touch. And then:
- **Connect what you're noticing to your inner world.** (Back to "the story of you": *What do you love, what don't you love?*). Notice—pay attention—to your responses when you look around you. Are you called to touch a certain fabric, and do you relish in the softness? Are you dazzled by an amazing color palette in an interior design magazine? Are you fascinated by the texture of brickwork?

Do you *love* the shape of a door handle? Does the smell of lavender inspire you? The sound of birds? Music/lyrics/books?

- **When you find inspiration,** record what you see/hear/feel and notice in your inspiration sketchbook or notebook and/or start a Pinterest account where you can upload images of everything that inspires you. Scribble, write, collage, paint, or glue *anything* you find inspiring: color palettes, textures, shapes, facial expressions, words, feelings that occur, book titles. Take photos of interesting compositions, contrast, shapes, and colors, print them out, and put them in your sketchbook. Gather information wherever you are, whenever you can.
- **Make time for inspiration gathering.** If you're someone with a very busy lifestyle and you find it hard to regard the world as a source of inspiration (because you're cooking the kids' food or you're on your way to work in traffic and everything is part of a distracting life, which is *totally* understandable!), try to **make specific time for inspiration gathering,** either daily, weekly, or monthly depending on your schedule. See page 50 for two additional exercises for this.
- **Be like a child.** When setting out to gather inspiration, look at the world with a childlike wonder. Children have an amazing imagination and see possibility in everything. An old tin can, to an adult brain, might appear to be just a discarded, unimportant can, but to a child it's the beginning of a space rocket that will take them on amazing adventures far into outer space.
- **Stop judging/labeling.** Try not to judge everything you see (for example: that's a pile of garbage/rubbish; it stinks). Instead, try to approach a pile of garbage with a childlike wonder and notice, really notice, the textures, contrast, and colors you might see there. Judgment can sit in the way of receiving inspiration. When we label and categorize everything, we dampen

our imagination and creativity and close the door to inspiration. Try to put the judging mind aside when you're going out to gather inspiration. Be willing and open like a child; allow crazy and innovative ideas to come to you in response to what you see/notice/experience.

- **Try new things!** Many of us are often in a predictable routine, doing pretty much the same tasks every day, seeing the same things every day, and cooking the same food every day. To get a new burst of inspiration/creativity, push yourself to try out new things. Allow new experiences to influence you, your art, and your life. Try out things you normally wouldn't. Maybe go horseback riding, take a stroll through a new forest, go to a carnival, dress up silly, or spray glitter in your hair. (Bungee jumping? Eek! Too scary for me!) Anything that's different to *you* can help fan a new burst of inspiration!

INSPIRATION & YOU

Here are some questions to ponder about inspiration and you.
- *Do you find it easy or difficult to find inspiration?*
- *Where do you currently look for inspiration, if at all?*
- *How do you feel when you find something that inspires you?*
- *When you're out and about, what kinds of things do you notice?*
- *What could you pay more attention to in terms of shapes, colors, textures, and so on, that could serve as inspiration?*

Exercises:
Gathering Inspiration

EXERCISE 1

What you'll need: A notebook or sketchbook, pencil, and a camera or a phone with a camera.

1. Start walking around your house, garden, or neighborhood with an open, childlike mind.
2. Look, feel, touch, and smell everything around you. Make notes/write/scribble things down in your notebook. If you find anything interesting—an old receipt, a dried flower petal, some fabric—gather and glue/collage it into your inspiration sketchbook. If you see interesting textures or fascinating shapes on walls/streets/the ground or anything else you want to remember to use for inspiration, take a photo, draw it, or write about it in your sketchbook.
3. Back at home, print out some of the photos you've taken and glue them into your inspiration sketchbook. If you've seen interesting color palettes, try to replicate them by adding color/ paints to your inspiration sketchbook.

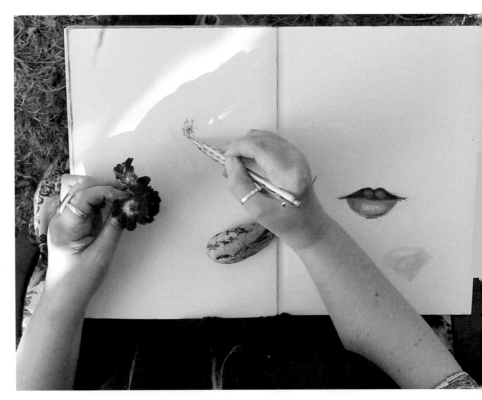

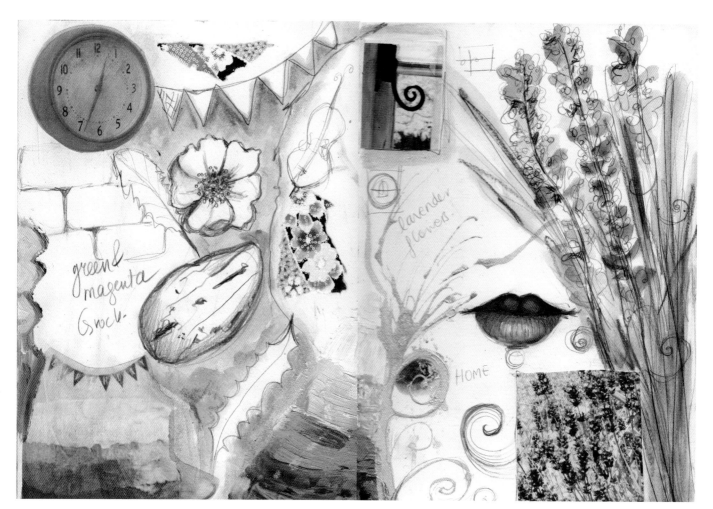

EXERCISE 2

Take two or three inspired finds from your gathering inspiration session and do one of the following:

- Choose one of the fairy tale lessons in this book and weave your found inspiration into the painting you make in the lesson.
- Choose a completely different fairy tale and create a painting challenging yourself to include two or three elements of your gathered inspiration.

For example, above is a spread in one of my inspiration sketchbooks where I sketched, collaged, and made notes of things that inspired me around the house and garden, from the teal in the kitchen clock to a pink layer cake and lavender flowers. I ended up creating a painting that included the color palette of the layer cake, the floral patterns of the lavender, and a repetition of a type of flower I found in the garden (see left).

The Goose Girl

"THE GOOSE GIRL" IS A GERMAN FAIRY TALE by the Brothers Grimm, who lived during the nineteenth century. It tells the story of a princess who's to be married to a prince in another country. She's sent on her way with a protective amulet, a waiting maid, and her horse, Falada, who is magical and can speak.

While on their way, the princess becomes thirsty and asks the maid to fetch her some water. When the maid refuses, the girl tries to get some for herself from the river and loses her protective amulet in the process. The maid decides to take advantage of the vulnerable princess and orders her to swap places by changing clothes and horses so she can pretend to be the princess. The maid threatens to kill the princess if she tells anyone, so the princess swears not to tell anyone who she really is.

When they arrive at the palace where the princess was to be wed, the now "princess-servant" is sent away with a boy to herd the geese and become the Goose Girl, while the maid who's pretending to be the princess orders Falada to be killed because she thinks it might tell the truth. Brokenhearted, the Goose Girl asks the slaughterer to nail Falada's head above the doorway she passes through with her geese every morning.

While out in the field, the boy herder wants to pluck some of the Goose Girl's beautiful strands of hair. She realizes this and says a charm that makes the wind blow the boy's hat away, thus keeping him at a distance so he can't grab her hair.

Angered by the "strange things" that happen around the Goose Girl, the boy tells the king that he no longer wants to herd the geese with her.

The king asks the girl to tell him her story, but she says she swore not to tell a soul. He suggests she tell her story to an iron stove, which she does, but the king eavesdrops and hears everything.

The princess is returned to her rightful position and marries the prince, while the maid (imposter princess) dies a horrible death, depending on which version of the story you read.

My Thought Process

I found this story somewhat frustrating, as the princess is described as rather fragile, helpless, and very dependent on others. I kept wanting her to have a bit more "spine," stand up for herself, and not be so helpless.

I also noticed myself having sympathy for the maid, as horrible as her actions were. This story speaks to the poor and unequal treatment of maids and servants in those times, and part of me could understand that the maid didn't want to "serve" the princess "yet again."

I was touched by the princess' care for and relationship with her horse, Falada, which I never knew was part of the story.

What I Wanted to Bring to the Story

I wanted the Goose Girl to have a sense of personal empowerment, to feel strong, and for her to have a voice instead of constantly being at the behest of either servants or royalty. I also wanted to emphasize her relationship with her horse and the geese, who I see as supporting characters that wanted the best for her.

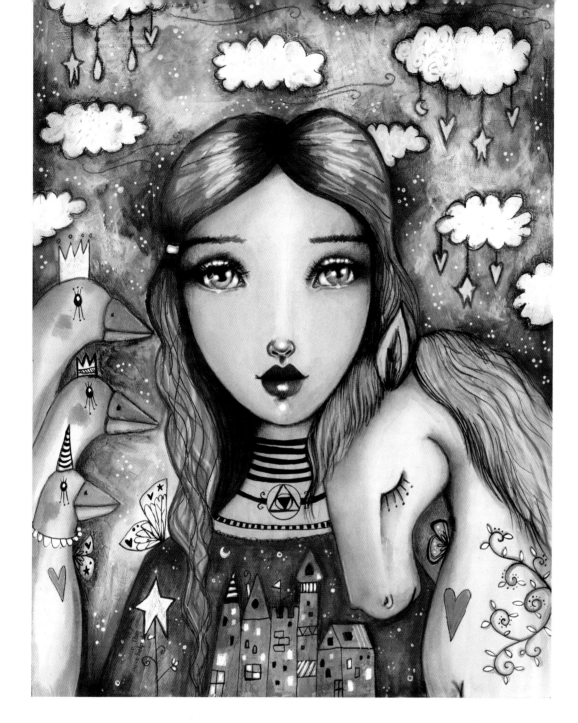

Part of me also felt pulled toward discovering more of the "evil" maid's story and somehow redeeming her by connecting with her pain and the tragic choices she made to meet her needs.

However, in the end, I ended up painting the Goose Girl with a central focus to emphasize her role in this story. I painted her with a childlike, innocent, somewhat fragile expression on her face, to capture her vulnerability, but, as I did with the stories of

Alice's Adventures in Wonderland (see page 32) and "Sleeping Beauty" (page 66), I added a (personal) symbol of "protection and strength" to her necklace, to give her some sense of empowerment. I also made her horse very prominent in the painting, as well as the geese, as I felt they symbolized love and support.

Finally, I added clouds and wind in the background to represent some of the power she did seem to possess through the charms she cast.

Create the Sketch; Begin to Paint

1. Draw/sketch the design of your Goose Girl painting (**A & B**).

2. Start painting the main character. I tend to start my Caucasian-skinned girls with a salmon skin tone with water-soluble crayons or watercolor paints (**C & D**). (See page 20 for advice on how to start darker skin tones.)

3. I then add details and build up darker shading with crayons, colored pencils, and markers (**E & F**).

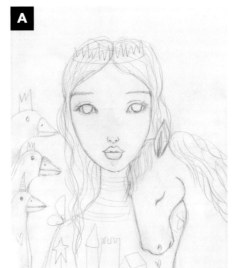

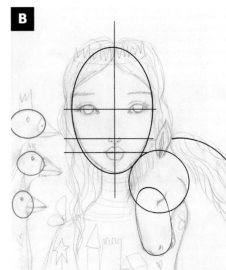

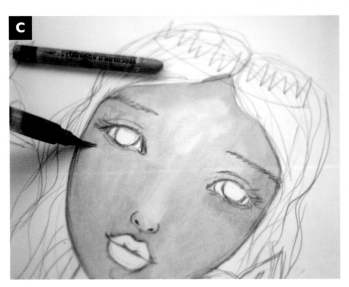

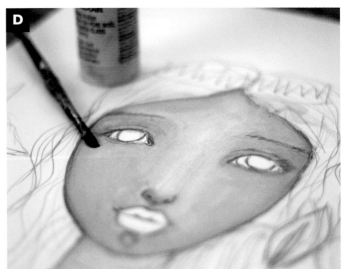

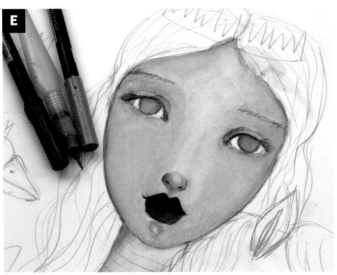

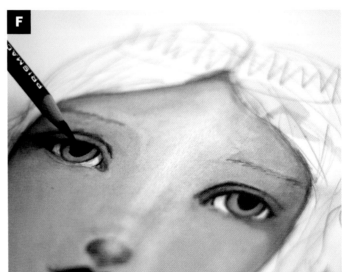

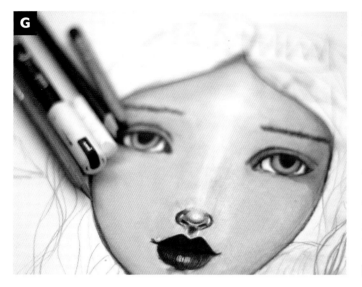

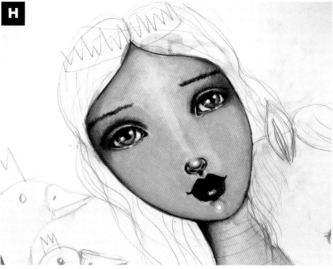

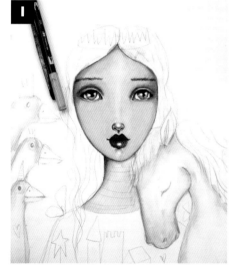

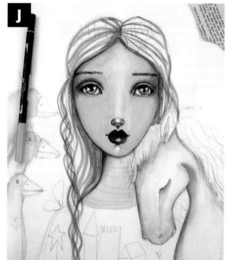

4. I add highlights with a white paint pen and emphasize shading with darker colored pencils (**G & H**).

Develop the Animals, Hair & Background

1. When most of the face is finished, add paint to the horse and geese with a water-soluble marker. I made the animals in a similar color scheme for a uniform feel (**I**).

2. With a Tombow marker, add strands of color to the Goose Girl's hair (**J**).

3. Add layers of collage to the background (**K**).

4. As a second layer, add water-soluble crayons in a variety of colors that fit my color scheme (lilacs, pinks, and purples). Also, add a layer of water-soluble crayons to the hair (I chose pink) (**L**).

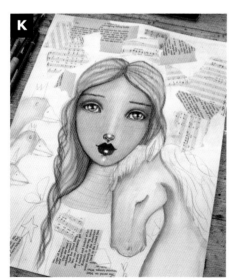

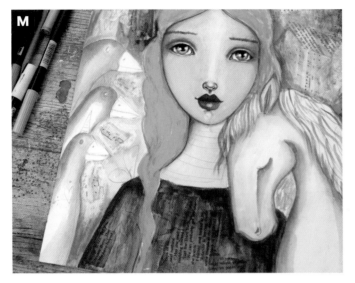

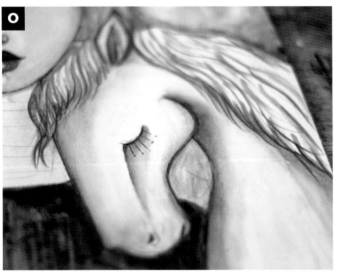

5. With inks and watercolors, add more shading to the horse and geese (**M**).

6. To bring unity and cohesion to the background, apply a layer of gesso with a brayer. The brayer leaves a textured/grungy effect that adds interest and depth (**N**).

7. With darker colored pencils, add final details to the horse and geese (**O**).

8. Add strands of hair with a purple marker. Apply and activate concentrated patches of watercolor crayons to create balance and contrast in the background (**P**).

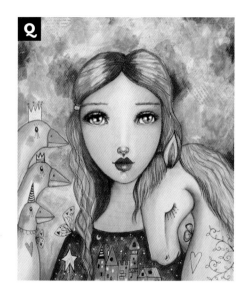

Refine the Hair, Add Doodles & Finish the Painting

1. Add contrasting strands to the hair, first with watercolor crayons, and then with a fineline marker. Now it's doodle time! I love to add symbolic doodles and imagery—butterfly wings, crowns, ruffled collars, hearts, stars, quirky flowers, childlike houses, and so on—to my characters and paintings. These are all specifically meaningful to me. You may find some specific symbols and imagery are meaningful to you. Check in with yourself and ask, "what wants to be spoken?", and then see what arises (**Q**).

2. To finish the background, add childlike clouds with a black colored pencil and STABILO pencil. The clouds represent the wind that the girl is able to summon. Use a white paint marker to bring the clouds forward and a blending stump to create a shadow around each one (**R, S & T**).

LESSON 6

The Little Mermaid

Guest Teacher Andrea Gomoll

Meet
Andrea Gomoll

Vibrant colors and playful layering make Andrea's artwork so eye-catching, uplifting, and happy-making. Andrea believes that creating art can help people get through rough days while making the "good days better," as she puts it. In this lesson, she works with the story of "The Little Mermaid."

"THE LITTLE MERMAID" IS A FAIRY TALE written in 1837 by the Danish author Hans Christian Andersen (1805–1875). It's a story about a young mermaid, living with her father and sister under the sea, who is willing to give up her life there and her unique mermaid identity to gain a human soul. After saving the life of a prince who would have drowned without her help, she can't forget about him or the idea of living a human life by his side. She sacrifices her beautiful voice to a sea witch who offers her the chance of a human life instead. To become a real human, however, she has to win the heart and love of the prince.

My Thought Process

Even though there are many teachings hidden in this fairy tale, one of the most important takeaways is to appreciate who you are and what you have. It's always good to learn new things and to be willing to explore something new, to have dreams, but don't forget to see and appreciate everything that you have already—all the small, beautiful things that surround you, the amazing being that you already are. It's easy to overlook those things if you're always striving for something different, bigger, and better. The grass always seems to be greener on the other side of the fence . . . but is it really?

The Little Mermaid is surrounded by so much beauty in the ocean—her family, her sea friends, beautiful things like seashells, seagrass, treasures—a wonderful, colorful, magical underwater world. She's beautiful and perfect the way she is, special in her own unique way with the special gift of an enchanting voice. However, she doesn't pay attention to any of this. She's only focused on that one thing she doesn't have; she is not a human soul.

What I Wanted to Bring to the Story

In my Little Mermaid artwork, I put my main focus on telling that story, on depicting that essence of the story in my own, personal style, which is colorful, playful, and whimsical. I wanted to focus on the unappreciated beauty that surrounds the mermaid in her life.

Whenever I try to tell a story with my mixed-media paintings, I try to focus on a few key elements that represent the different elements of the story: the shoes represent her longing to be a human, to have feet, to be able to walk; and the music-notes represent her voice/ability to sing beautifully, this way you can easily tell a story without using a single word. I added key elements to my work representing the beauty and uniqueness of her life under the sea (shells, sea-buddies, an anchor as a symbol for her being bound to her life under the sea). I surrounded the Little Mermaid as the main figure by all these elements in the mixed-media painting; however, she only has eyes for the pair of shoes in front of her.

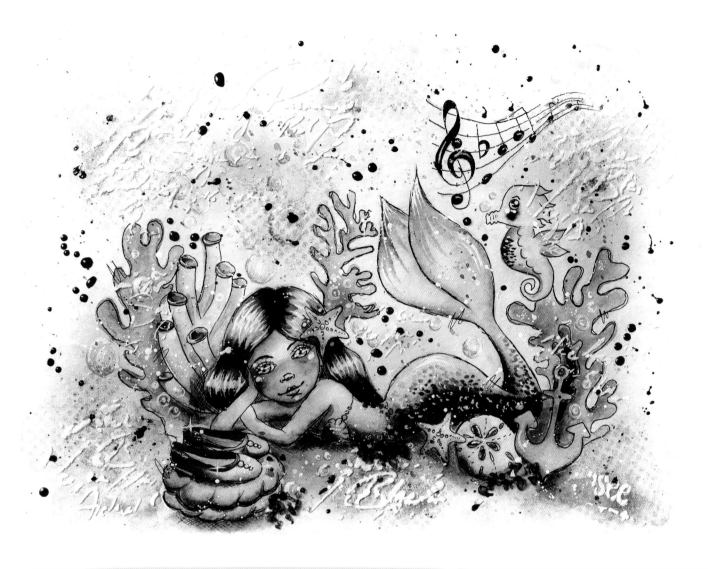

ANDREA'S TIPS FOR DEVELOPING YOUR OWN STYLE

- *Always stay open and try new things*—*different styles, different combinations of art supplies, and so on—to keep your work fresh and the process fun.*
- *Never compare your work to anyone else's.* *Your work is never better or worse, it's just different—that's what makes it unique.*
- *Always enjoy the process.* *Never put too much pressure on yourself to "find" your own style. Over time, your own personal style will find you; it will automatically evolve.*

Draw the Little Mermaid

1. Start sketching the mermaid, making sure to leave enough white space around her for the additional elements. Start with an oval for the head and use this as the reference point to add the rest of the body. Use circles where the joints should be, as guidelines to build up the full body step by step. Start with basic shapes for the body parts (**A**).

2. Refine the body elements, adding roundness to the female body. Don't be afraid to go over the lines a couple of times until you're happy with the result (you can always erase). Add hair and sketch in guidelines for the facial features (placement lines for the eyes, nose, and lips) (**B**).

3. Add the facial features. For the eyes, start with simple ovals on the eye line. Add the iris and pupil and then redefine the final eye shape. Add a tiny line above the top eyelid and some simple eyebrows. For the nose, start with two tiny nostrils, connect them with a tiny curve in the center, and then add two little curves to the left and to the right. On the lip-helping line, start with the top lip in the shape of a wide stretched "m," and then add a tiny curved line below it for the bottom lip. If you're working on a small face, keep the facial features simpler. Too many details can easily overpower it (**C**).

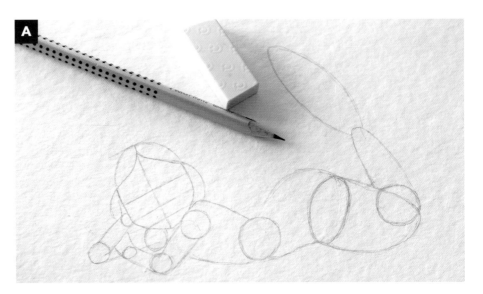

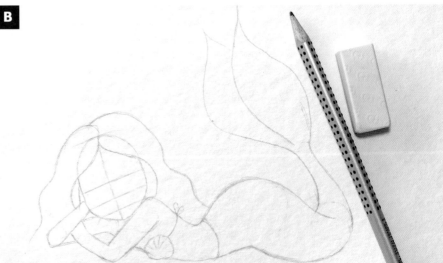

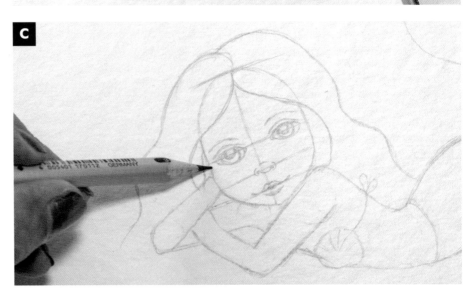

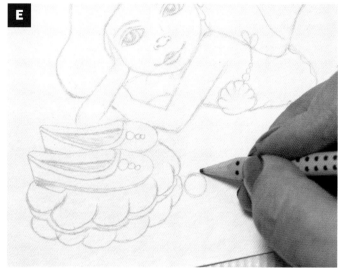

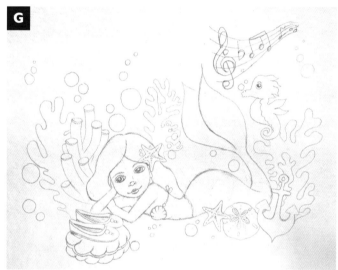

4. Sketch in all the additional elements (seashells, seahorse, shoes, and so on). Always start with a simple, basic shape and then redefine the lines and add details, moving step by step toward the final shape. Add some seaweed to connect the mermaid and all the other elements in a scene. Work with a very loose, wavy line forming the seaweed. Also add small circles of different sizes everywhere to symbolize air bubbles, underlining the impression that this scene is taking place under water (**D, E, F & G**).

Paint with Watercolors

1. Once you're happy with the scene, start the coloring process with watercolors. Add a flesh/peach color to the skin, beginning with color in the darker areas, and then softly blend it into the lighter areas that catch more light. This way you create some dimension with just one or two colors. Add light pink to give her rosy cheeks (**H**).

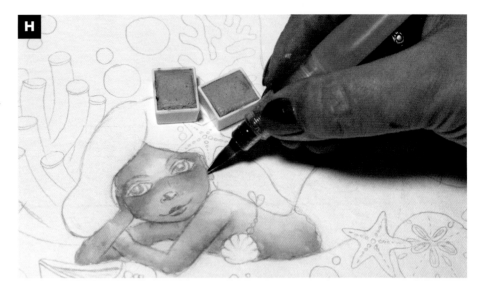

2. Apply color to the rest of the mermaid. For a playful, colorful look, use two to three different coordinating colors and let them blend wet-in-wet on the paper (**I**).

3. Choose two or three coordinating colors in green/blue/turquoise. Using lots of water, add the colors to the background. Let the colors blend and bleed into each other. Add more water or color where needed (you can also dab off some water with a paper towel if larger puddles form on the paper). Enjoy watching the watercolors "do their own thing" and create unique patterns (**J**).

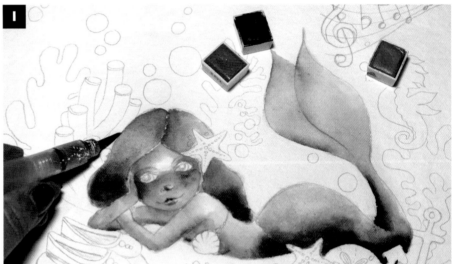

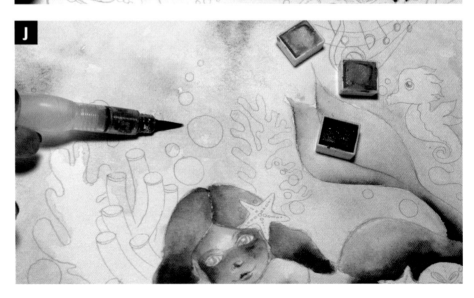

4. Once the background is dry, you can paint in all the other elements. Make sure the color-feel matches the mermaid for a uniform, balanced look. Always start with a first, very light base coat of your colors and let them dry completely (**K & L**).

5. Once the first layer of color is dry, go back in to add more depth and definition and create more dimension using a darker shade of your base color, applying it close to the outline of your objects and blending it inward. Then grab some purple or dark blue, applying it softly along the outline and at the bottom of the objects to create shadows (**M**).

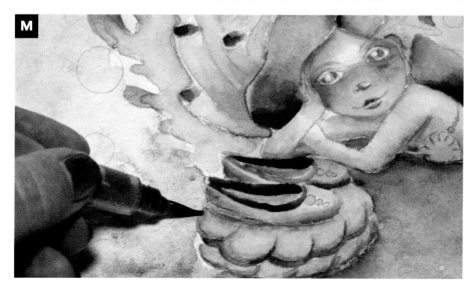

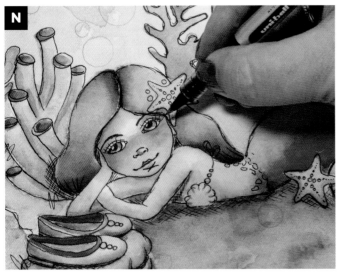

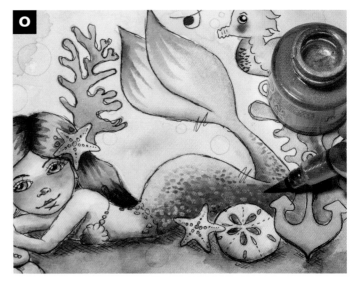

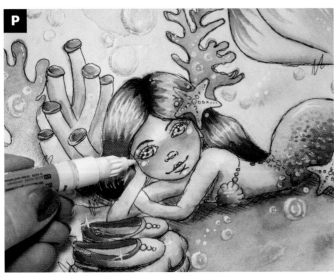

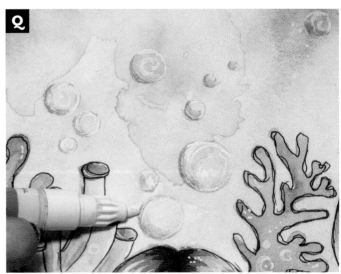

Refine Details & Add Highlights

1. Once everything is dry, use a black waterproof fine-tip pen to bring back details that might have gotten lost during the watercolor process. Add a loose, sketchy outline to all the elements and add some additional tiny swirls for a playful, whimsical touch. You can also add a bit of loose crosshatching to the shadow areas to darken them even more (**N**).

2. Use a darker shade of the color you used for the mermaid tail and add tiny dots and "u" shapes for texture. Use a gold watercolor or ink for texture and a little bit of shine and sparkle (**O**).

3. This step is one of my favorites because it makes a big difference in the overall look. Use a white, fine-tip paint marker to add some highlights and catchlights to the mermaid's face (eyes, cheekbones, tip of the nose, and chin) as well as to her hair and tail. Also add highlights to the other elements, such as tiny white sparkles to the shoes. The additional white makes the whole scene come to life (**P**).

4. Outline all the little air bubbles with some white, adding some white lines/ reflections to the inside of the bubbles as well, always following the round shape. Add hints of color (purple, green, yellow) to the bubbles to create the merest bit of color reflection and to help them pop off the background (**Q**).

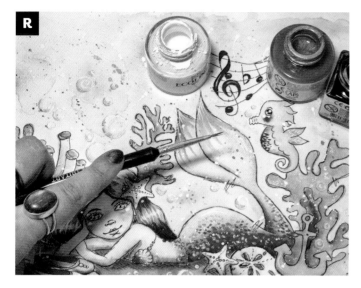

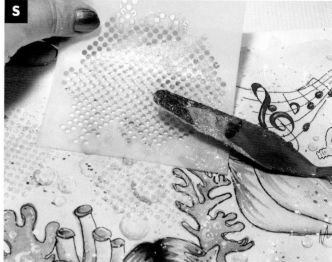

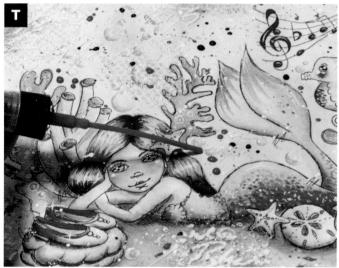

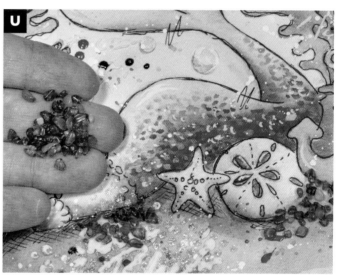

Embellish with Mixed Media

5. Grab some white, gold, and turquoise liquid watercolor or ink. Load your brush with a watery mix of the color and slightly tap it with your finger to add some tiny paint splatters to the whole piece for a playful touch. Let the different color splatters dry before adding the next color. If you don't want splatters to go in some areas (like the mermaid), shield it with your hand or some paper (**R**).

1. Once everything is dry, add a fun mixed-media touch. Use some texture paste of your choice (clear with glitter, white, or a color of your choice). Find some nice stencils and apply the texture paste over them using a palette knife. This will create a fun raised texture that adds lots of interest (**S**).

2. Using the nozzle of a bottle of dimensional texture spray, I added some additional little "bubbles" to the project. They dry raised and shiny, for an enameled dot look (**T**).

3. Last but not least, I used a clear drying gel medium to add tiny amber chips to the scene for another fun dimensional element (**U**). It's also a nice connection to water because Baltic amber is found in the ocean. (You can also use other real ocean elements, such as tiny seashells or beach sand.) The final piece comes together with additional elements and symbols to reflect personal style and meaning.

Sleeping Beauty

"Sleeping Beauty" (also known as "Little Briar Rose") is a well-known classic fairy tale about a beautiful princess who falls asleep for one hundred years after an angry fairy casts a sleeping enchantment on her. The princess is later awakened by the kiss of a fetching prince who breaks the enchantment. The story was originally written by Charles Perrault, who also wrote a version of "Little Red Riding Hood" (see page 18). The version by the Brothers Grimm was shared orally and based on the original story by Perrault. Looking further into the history of this story, there are many influences. Perrault's story was inspired by/based on the story "Sun, Moon, and Talia" by Italian poet Giambattista Basile (1566–1632), and his story in turn was inspired by several folk tales.

My Thought Process

When looking further into the history of "Sleeping Beauty," I found that Perrault's and the Grimms' versions are the closest to the modern tale we know today. Looking at Basile's version, which is quite different from the modern version, I found some very disturbing details in the story, including a king who impregnates Sleeping Beauty while she is unconscious. In the modern story, too, Sleeping Beauty is the victim of violence (the fairy's enchantment). I feel that Sleeping Beauty is targeted in all versions of this story and that she needs a strong sense of strength and power: I wanted her *protected*.

What I Wanted to Bring to the Story

I wanted to paint Sleeping Beauty centrally, in all her glory and beauty, surrounded by roses and thorns. I wanted to keep the focus on her, tell her story, put her front and center, so she could be seen and known and celebrated. And I also wanted her to be and feel more protected and have a sense of empowerment and strength, so I used my personal symbology (see sidebar on page 33) to add a symbol of protection, power, and strength to her forehead.

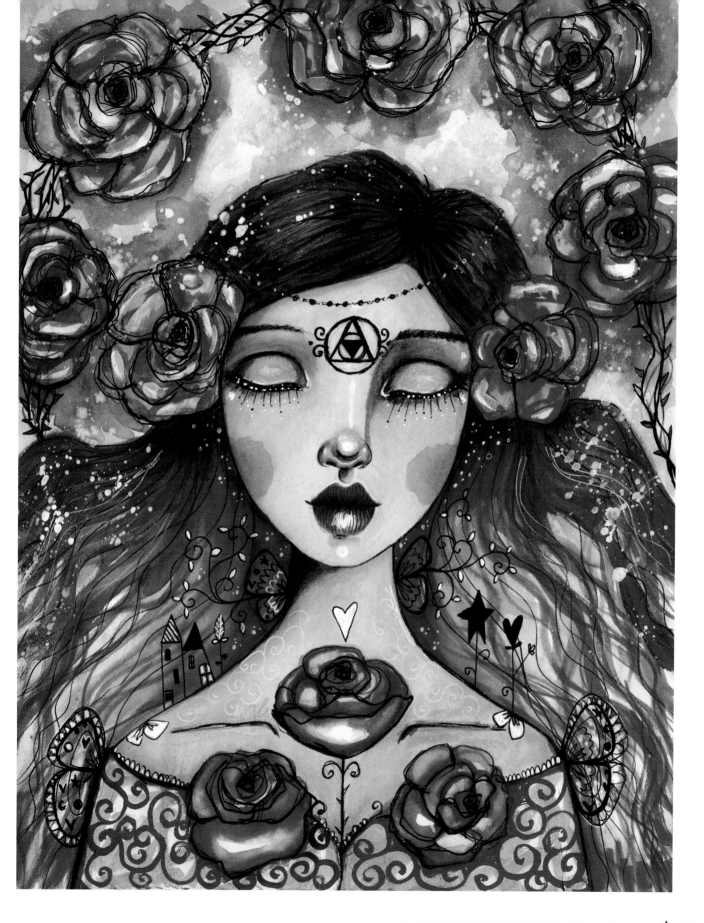

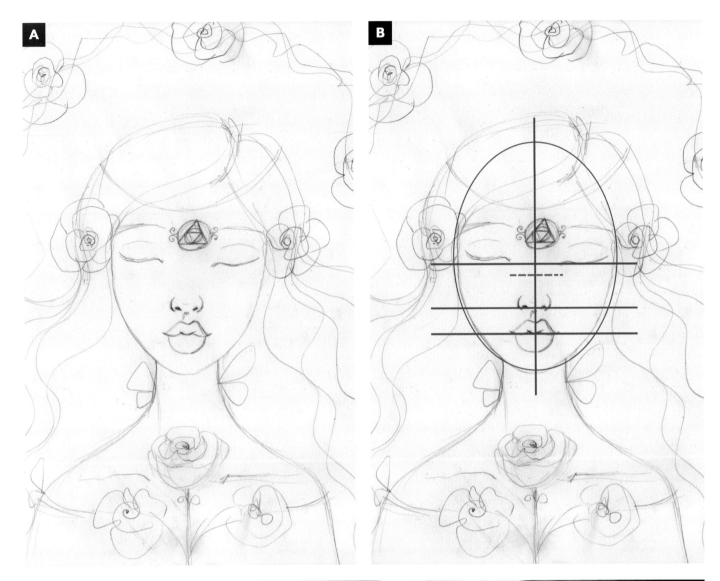

A

B

Create the Sketch

1. Sketch the design. I added my personal symbol of protection and power between Sleeping Beauty's eyes (**A**, **B** & **C**).

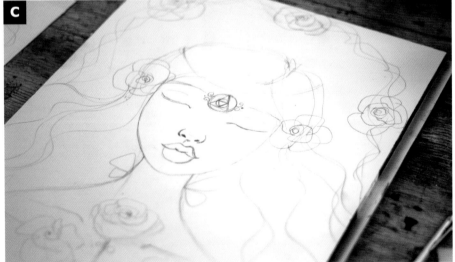

C

1

2

3

4

5

6

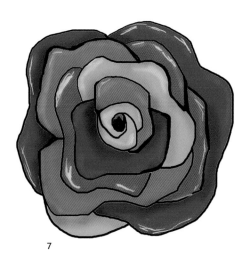

7

2. Follow these steps to fill in the background with simple roses (**D**).

Paint Sleeping Beauty

1. Start painting Sleeping Beauty. I usually start my Caucasian-skinned girls with salmon-colored water-soluble crayons or watercolor paint. Here I created shading by concentrating darker tones around the eyes and the edges of the face (**E, F & G**). (See page 20 for advice on how to start darker skin tones.)

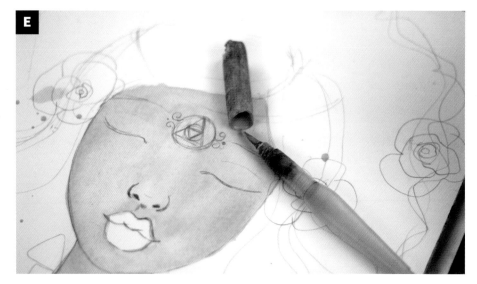

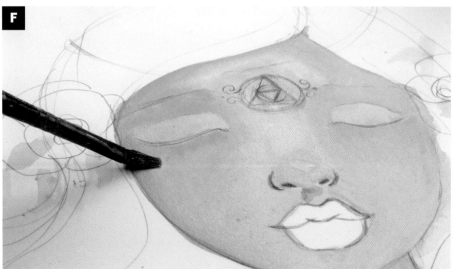

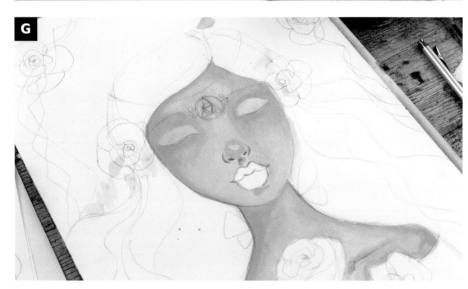

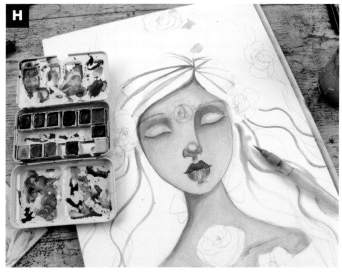

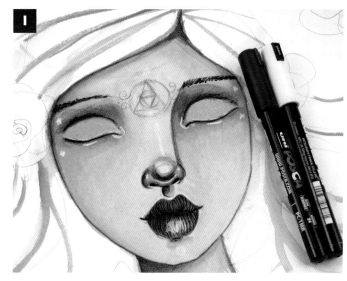

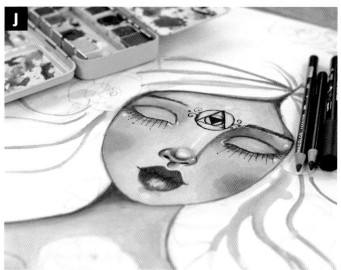

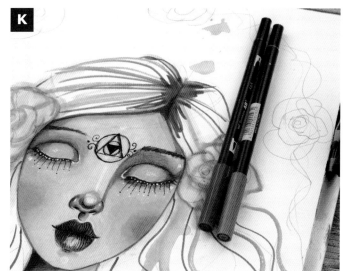

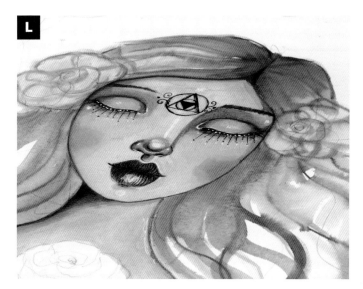

2. Use watercolor paints, colored pencils, and paint markers to enhance the shading and add details to the face and hair (**H, I & J**).

3. Add strands of color to the hair with water-soluble ink markers, and then activate with a spray bottle with water (**K & L**).

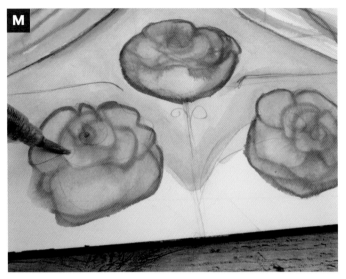

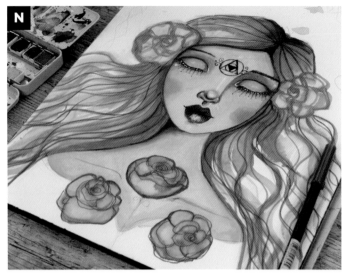

4. Use the same markers to color the roses. Activate the markers with water and they become paint-like (**M**).

5. Continue to build up the hair with markers and watercolor paint (**N**).

6. Paint Sleeping Beauty's dress with a dark pink paint marker, and then shade with red. Also use paint markers to add line work to the roses (**O & P**).

Add Doodles & Details

1. Doodle time! I like to add imagery and doodles that are meaningful to me (**Q**).

2. Add a wash of white acrylic paint to Sleeping Beauty's dress (**R**).

3. Add a wash of pink watercolor paint to the background, let dry, and then spatter it with diluted white acrylic paint. Load the paint onto a brush and gently tap it around the surface; this creates a magical effect. You can also add spatter to Sleeping Beauty's hair. I finished Sleeping Beauty's dress by decorating it with swirls of dark pink marker, which I then filled in with a lighter pink marker (**S, T & U**).

The Little Match Girl

Guest Teacher Kara Bullock

Meet
Kara Bullock

Kara's work, mostly portraits, evokes depth and emotion. I love her impressionist style and brush strokes and the intensity of the characters who often seem to have an important story to tell. For her lesson, she works with the story of "The Little Match Girl."

THE SHORT STORY "THE LITTLE MATCH GIRL," written by Hans Christian Andersen (who also wrote "The Little Mermaid"; see page 58), is about a young, poor girl who's trying to sell matches on New Year's Eve. It's freezing cold outside, but she's terrified to go home for fear that her father will beat her for not selling any matches. Instead, she finds a corner between two homes to take shelter in. There she begins to light the matches one after another to help keep warm. To her surprise, with each match, she has a beautiful vision. The first is of a warm stove. Next, she sees visions of a magnificent Christmas tree with glowing lights and a gorgeous holiday feast where the duck on the table comes to life. The most beautiful vision she has is of her grandmother, the only person in her life who made her feel loved. As the match burns out, she loses sight of her grandmother. To keep the vision glowing brightly, the Little Match Girl strikes the entire bundle at once! When the matches finally burn out, the grandmother carries the little girl's soul to Heaven.

The next day, passersby find the little girl frozen to death. They guess she was burning the matches to keep warm and feel sad they hadn't found her before it was too late. Little do they know of all the wondrous visions she had before dying and how happy she was to be in Heaven with her favorite person, her grandmother.

My Thought Process

As I was reading this story, I was reminded of what really matters in life. We get caught up in so many materialistic things, but really what we ultimately need is to be loved. For a child, that also means meeting his or her basic needs, such as being fed and sheltered. If our basic needs are met, we can thrive in this world. Sadly, the only person that seemed to be able to give the young girl what she needed had gone to Heaven. The Match Girl's basic needs were no longer being met. The young girl was afraid to go home for fear that she would be beaten for not providing for her family. What a heavy burden for a child to carry. However, when lighting the matches, she was able to feel happy and remember that she had been loved and what that felt like. It reminded me just how important it is to feel loved. This story also made me reevaluate my life and the lives of my children. We can give our children material things, and they'll feel happy for a moment, but what they really need is love from their parents and those around them. Love is truly the greatest gift!

What I Wanted to Bring to the Story

I wanted to emphasize the glowing lights that the girl saw with her visions. With each match, she felt alive and happy, and I wanted to portray this feeling in my painting. I didn't want to paint a picture of a poor, sad, dirty little girl. Rather, my image for this piece was of a happy girl full of beautiful memories of her loving grandmother. With the lighting of the matches, she was able to have wonderful memories

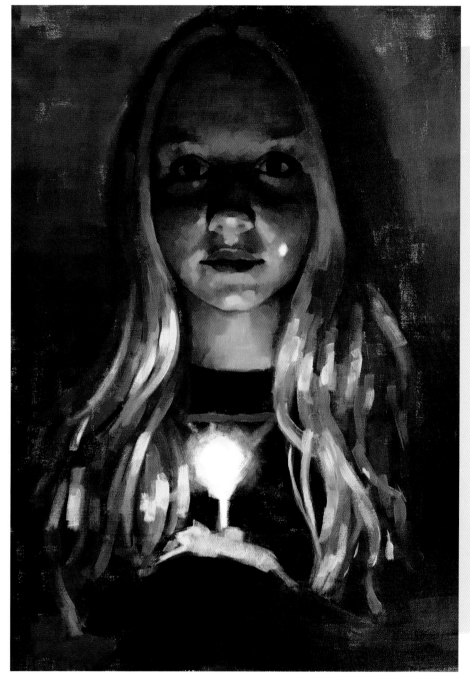

KARA'S TIPS FOR DEVELOPING YOUR OWN STYLE

- **Study other artists and think about what's really appealing to you.** *What type of art do you want to make? What speaks to you? What are you drawn to? Start taking classes or lessons that can help you move in that direction.*
- **Study artwork that you aren't as drawn to.** *Take workshops or classes that might be totally opposite of your liking. You'll be amazed at how fun it might be and also how it might add to your skillset. I often find that when I take something that's the opposite of what I normally do, I learn something totally new and valuable that then helps me to move forward in my own art.*
- **Try not to have expectations when you go to your easel.** *Remember to enjoy your time creating and not to worry about the end product. Taking the pressure off yourself will only help your art to grow and will remind you why you started in the first place! For most of us, we began making art as a stress reliever or to have some fun! Don't forget that!*

of being loved, and I feel that this took her to another time in her life when she wasn't in need or want of anything.

I try to always see the light or positives in a situation rather than focus on the dark. While I realize that this young girl was in a dire situation, I love that she was able to see the light that had been in her life. I think that when we can focus on the light in our lives, it can help to bring us out of dark situations and move forward and thrive, even when it's hard. I want to be reminded to light matches in my own life when things get dark. I think I'm going to carry my own book of matches, just to have that daily reminder. I encourage you to do the same!

Find and Edit the Reference Photo

1. Take a photo of—or search online for an image of—a young girl holding a match in the dark. The quality of the picture isn't important. My photo for this lesson was quite grainy (**A**).

2. Using the Enlight app, or another photo-editing app or software you're comfortable with, manipulate the photo. Upload your image and then choose the following settings (using Enlight): Artistic > Painting > Dahlia. Swipe your finger to the right to create a more painterly image. You can play with additional features if you want to change the colors as well (**B**).

Paint the Little Match Girl

1. Paint a light wash of burnt umber light transparent over your entire canvas. Don't worry about filling in all the white spots. Then, using a posterized version of your edited photograph as a guide (**C**), draw an underpainting of your portrait. I used burnt umber transparent and a mix of carbon black and pyrrole red for the darker areas (**D**).

2. Begin blocking in some of the darker areas on the forehead and under the eyes. I used a mix of pyrrole red, yellow oxide, and Prussian blue. Add more blue if you want to darken the color; the lighter tone has less blue (**E**).

3. Next, block in lighter, brighter colors for her skin. In this case, I used the pyrrole red and yellow oxide. To neutralize and darken the color, add Prussian blue. To create lighter hues, add white. For a more pinkish tone, add more red. For more of a yellow tone, add more yellow (**F**).

4. Continue to work your way around the face. Add layers to create depth. Slowly work in details of the eyes, nose, and mouth. The whites of her eyes are very dark, so pay close attention to how they change. Block in some of the background, including her hair, to gauge the contrast between the face and background (**G**).

5. As I put in more detail, I saw that I needed to address the hair, her body, and the light. I slowly began to block in these parts. For the light I used a mix of yellow oxide, black, and white. As it gets brighter, I added some cadmium yellow (**H**).

6. Continue to layer the paint in varying shades of the skin tones in your image. Block in the hair. Pay attention to where the light is hitting the hair. Brighten the light of the match (**I**).

7. Add the brightest layers. Give a suggestion of her arms and hands, but don't put in major details. Let the mind fill in the rest. Add last-minute highlights to the face and hair. Lighten the background toward the top to show the light. Sign your name (**J**)!

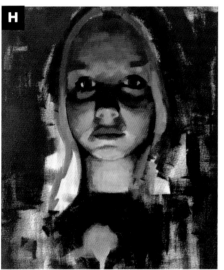

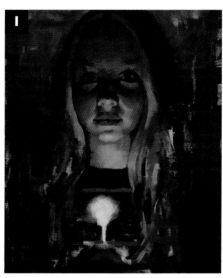

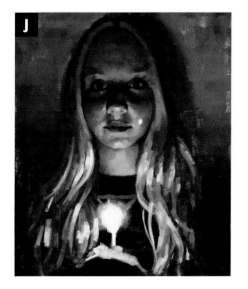

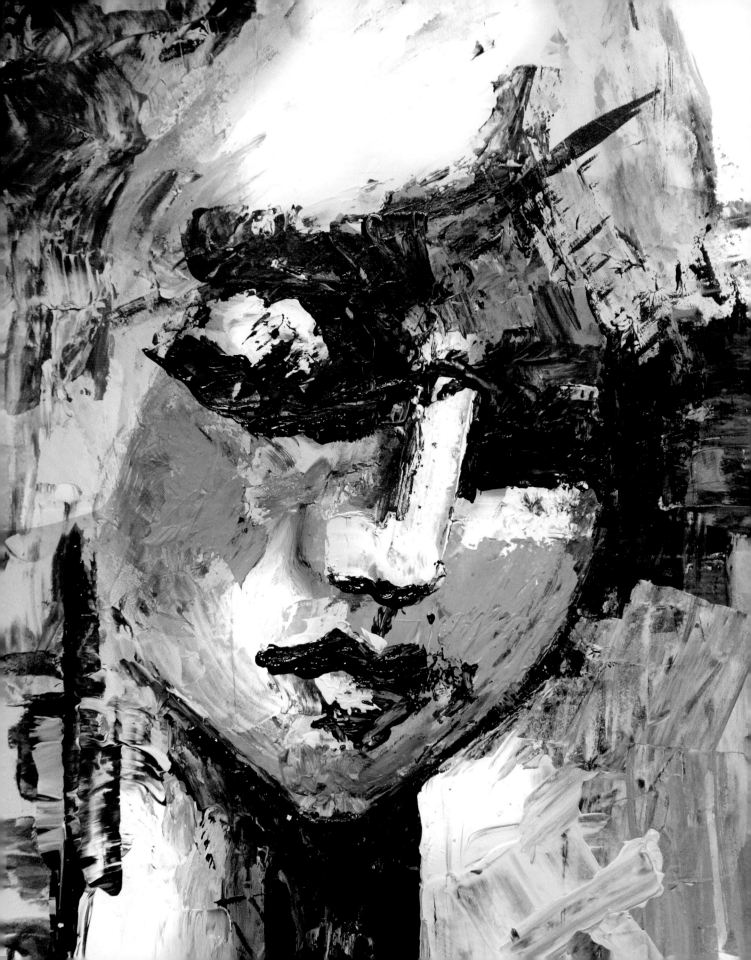

3
Comfort Zones & Productivity

ONCE YOU'VE ESTABLISHED FAMILIARITY and confidence in your style, methods, and storytelling, it's time to look at ways and methods that help you deepen your own style and voice.

One really great way to take things "to the next level" is by starting to move away from our creative comfort zones, to go beyond those boundaries and start doing some different, possibly uncomfortable and unpredictable things.

In my personal journey as an artist, I found that when I did things that I at first resisted or that scared me, bored me, or that I didn't like, I grew as both an artist and as a person, and it helped me further develop my own voice/style.

It can feel scary to do things that we feel resistance toward. Our comfort zones are aptly named because they feel so *comfortable*, of course! But as we all know, *the magic happens* when we explore and move far beyond those cozy boundaries.

When we step outside of our comfort zones, the idea isn't that we adopt things that we really *don't* like, but instead we continue to explore beyond our comfort zones while continuing to follow "our bliss" by checking in with ourselves about what we do and don't like and what truly lights us up. Only bring back with you that which resonates with you and makes your heart and soul sing.

Shown opposite is an example of me working out of my comfort zone. I painted this piece using only palette knives, which was a real challenge for me!

Another element of style development covered in this chapter is productivity. While we've established that developing one's own style and voice can take time, this process can be expedited when we consciously and purposefully set out a dedicated time, preferably daily, for our creative practice.

Stepping Out of Your Comfort Zone

Instead of following your bliss this time around, I'm asking you to temporarily follow *your fear*, or at least follow your resistance, or follow the *thing that seems challenging to you*. When you notice resistance to a particular art technique or style, you can bet your bottom dollar that great learning and growth is hiding in the corner right there with it. So take that leap of faith and break out of your comfort zone into more uncomfortable areas of creativity.

What happens when we take the plunge into these unknown territories?

- We allow ourselves to be exposed to, explore, and learn from the wider art community and the myriad approaches there are to the creative process.
- We allow ourselves to discover new ways of creating we thought we didn't like but actually (possibly) do.
- We allow ourselves to grow by having to overcome new challenges that we didn't need to look at while in our cozy comfort zones.

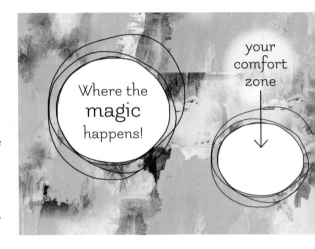

Where the **magic** happens!

your comfort zone

- We allow ourselves to deepen our understanding of the creative process, methods/techniques, and approaches that may or may not come with us into our own creative processes.
- We give ourselves the opportunity to grow our own voice by finding new and exciting ways to create.
- We face our fears, nurture creative courage, and learn to deal better with our inner critics.

Now, what scares me might not scare you and vice versa, so the exercises we attempt to challenge us out of our comfort zones will differ for each person.

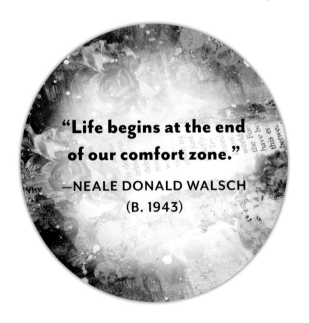

"Life begins at the end of our comfort zone."
—NEALE DONALD WALSCH
(B. 1943)

Exercises: Do It Anyway

Here are some ways of creating that I find challenging and get me right out of my comfort zone:

- Creating intuitively/loosely/freely without a plan. (I have heart palpitations just reading that. Hello, control freak—ha ha!)
- Limiting my supplies to either a few or only one (biro/ballpoint only, or crayons only).
- Changing my subject matter drastically from the usual girls/faces, such as:
 » *older males*
 » *landscapes*
 » *cityscapes*
 » *realistic animals*
 » *fruit*
 » *vehicles*
- Working with my non-dominant hand/my eyes closed/fingers only or limiting my tools (for example, I can only work with a palette knife; no brushes or drawing tools allowed).
- Taking classes from people whose methods and techniques are very different from mine and/or whose art I don't necessarily find appealing.
- Working backward from my usual process. (I usually start drawing and then build up paint layers; it's less comfortable for me to start with a messy paint background and then bring in the drawing and shapes.)

- Combining unlikely supplies (I once used crushed eggshells!) or sticking to only one style/ method (creating a piece of art with collage only).
- Allowing for negative space by not filling up the entire page. (Oh no! There's a bit of white there!)
- Choosing colors you have a tricky relationship with (for me, it's red) or choosing color combinations you usually struggle with.

Effectively, to help deepen your voice and style, it's really helpful once in a while to step away from what you usually do. As another example, I used to stay clear of ultramarine blue. I disliked that color with a vengeance. (I blame my time in art school, but who knows why!) Recently, an ultramarine blue Tombow was lying on my desk, staring me right in the eye with its icy blueness, and I don't know what came over me. It may have been sheer courage, or laziness to reach for another color, but I grabbed it and combined it with a bright red.

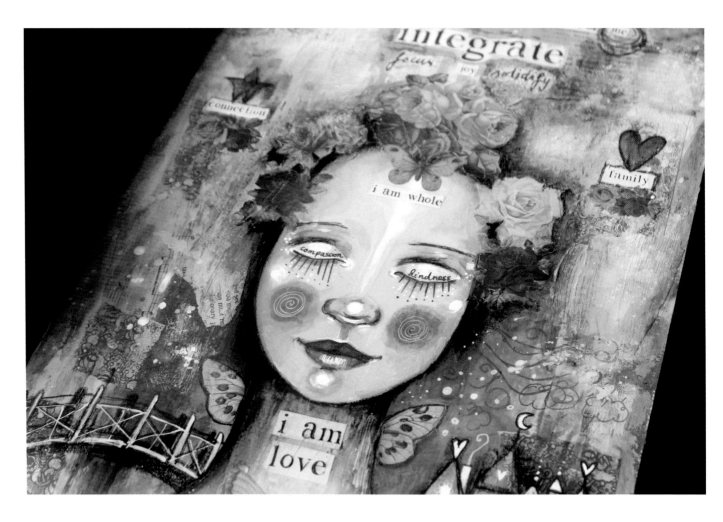

And guess what happened? I created this painting above. And I love it more than many of the things I've ever created. This was growth for me, this was me developing my style, my voice, broadening my horizons, and I hadn't even deliberately set a challenge!

Now, you may already love the combo of primary blues and reds, so you have to challenge yourself to use olive green and gray together (or whatever color combinations you feel a lot of resistance toward).

Also note that stepping out of your comfort zone can happen in baby steps. I only used two colors I usually felt resistance to, but big things happened because I took those baby steps. I didn't even need to take a giant mega step to get a bit further with my voice and style.

Exercise: Comfort Zones vs. Fear Zones

To explore this further, take a moment to write down all the creative approaches/colors/techniques/styles/ methods, etc. that fit in your comfort zone and the ones that fit in your fear zone.

Committing to Productivity

While we've established that developing one's own style and voice can take time, this process can be expedited when we consciously and purposefully set out a dedicated time, preferably daily, for our creative practice.

One can muse and dream about making art in one's own style, but one thing that should not be overlooked is that we all need to put in the time and work. When we get more serious about our artwork and really want to commit, allocating a set time daily or weekly to our art is a must.

Because many of us live hectic lives, art making can become important but overshadowed and swamped by all the other "urgent" things. It's super important to purposefully *make the time* for our art if we deem it important to develop our own style. It's simple really. In order to develop your own style, **you have to do the work**. The more work you do, the sooner your skills develop, your voice will emerge, and the quicker you will find clarity and growth.

Before I had children, I used to go through phases of setting myself a daily challenge of doing *some* small art in my Moleskine notebook every day. I managed to fill up pretty much three to four journals over a period of a year and half. My skill, insight, personal well-being (because I journaled), and my voice all deepened tremendously during that time. If you can somehow manage it, I can't recommend strongly enough to set aside at least twenty to thirty minutes a day for art.

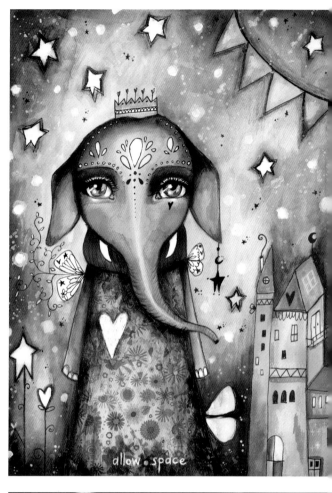

The Snow Queen

"THE SNOW QUEEN" IS A FAIRY TALE written by Danish author Hans Christian Andersen in 1844. The story focuses on the struggle between "good and evil" through the experiences of two children, Gerda and Kai.

The story involves a mirror created by an evil troll (the devil) that reflects only the "bad and ugly" when someone looks into it. At some point the mirror breaks into billions of little pieces, and some splinters of the mirror fall into Kai's eyes and heart, which makes him see only the ugly in people and the world. He becomes cruel, unfriendly, and aggressive toward his close friend, Gerda.

The next winter, Kai goes out to play with his sled and meets the Snow Queen, who appears as a woman in a white fur coat. The Snow Queen makes Kai forget about Gerda and his life and takes him away to her palace.

Gerda then goes on a journey to save her friend. She has many adventures on her way to find Kai. She eventually finds him and he is saved by the power of her love and warm tears, which melt his heart and burn away the pieces of mirror inside of him.

My Thought Process

Throughout my life I've found this story fascinating as I could never quite understand the personality of the Snow Queen and what her motivations were for taking Kai. Though the story is called "The Snow Queen," it actually focuses more on Gerda and her adventures. I was always more drawn to understanding the relationship between the Snow Queen and Kai, which I felt was never clearly addressed in the story.

What I Wanted to Bring to the Story

Since starting my journey as a mother nine years ago, I'm drawn to thinking that the Snow Queen represents the yearning of a woman who can't have children. This isn't alluded to in the original story, but whenever I see artwork and imagery depicting the Snow Queen and Kai, often shown in intimate embrace, I cannot help think that this is a woman who yearned to have a child, couldn't have one, and therefore stole one.

I've struggled with infertility (my first child was born through IVF), so perhaps this is what skews my interpretation. But this is how I enjoy approaching stories; I respond to what is stirred in me when I'm reading.

What do these stories stimulate/stir in *you*? Remember that what you're seeing/feeling in response to the stories doesn't need to be how the author wrote them. Use these stories as a "springboard" to explore your *own* story and excavate what's "alive" for *you* when you read them.

For this lesson I felt called to paint the Snow Queen in close embrace with a young child. I also included the crow, which to me often represents "dark and difficult themes" and is mentioned as a character in the land of the Snow Queen.

I painted this piece with a combination of purples, blacks, and whites to give the painting a cold, wintery feel and worked with molding paste and stencils to create the illusion of ice and snowflakes in the background.

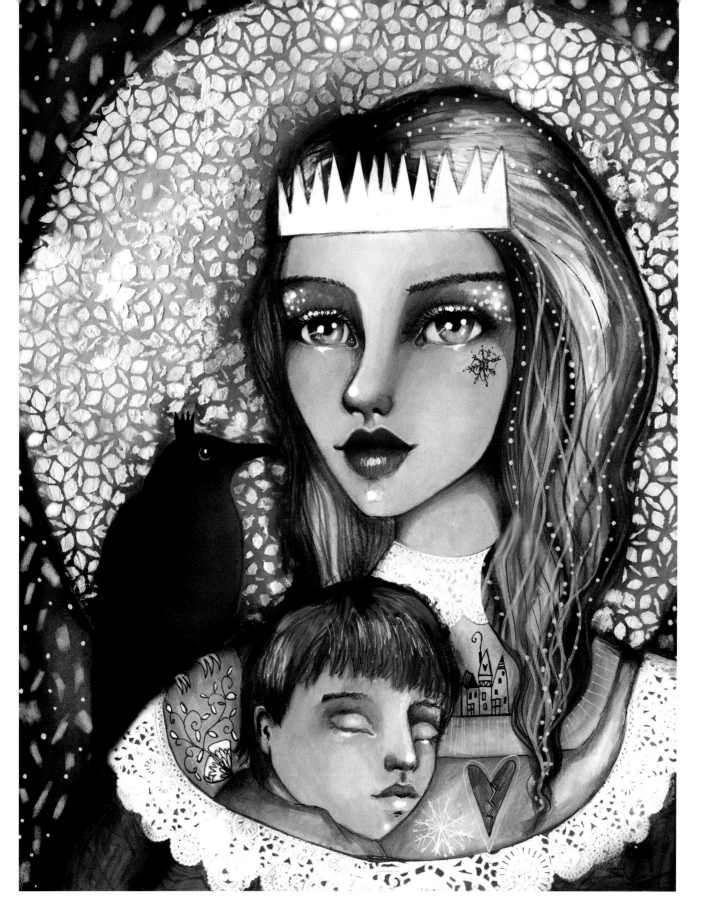

Sketch the Design

Draw/sketch the design, following the guidelines showing proportions of the various elements and placement of the features (**A & B**).

Start to Paint

1. For both the Snow Queen and the child, which I depicted as having Caucasian skin, I started with a salmon skin tone, which I create with either water-soluble crayons or watercolor paints (**C & D**). (See page 20 for advice on how to start darker skin tones.)

2. I built up darker shading and start some of the details with crayons, colored pencils, and markers. I then added highlights with a white paint pen (**E & F**).

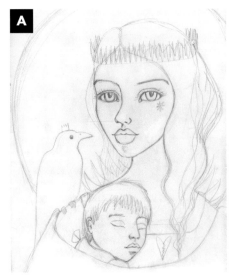

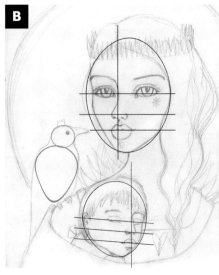

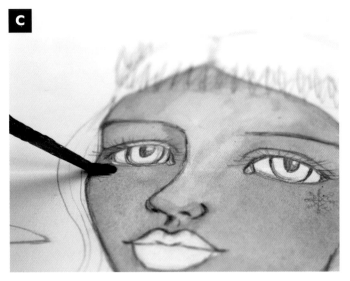

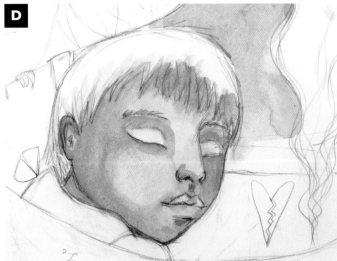

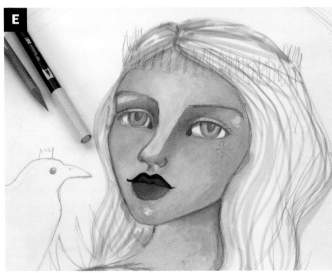

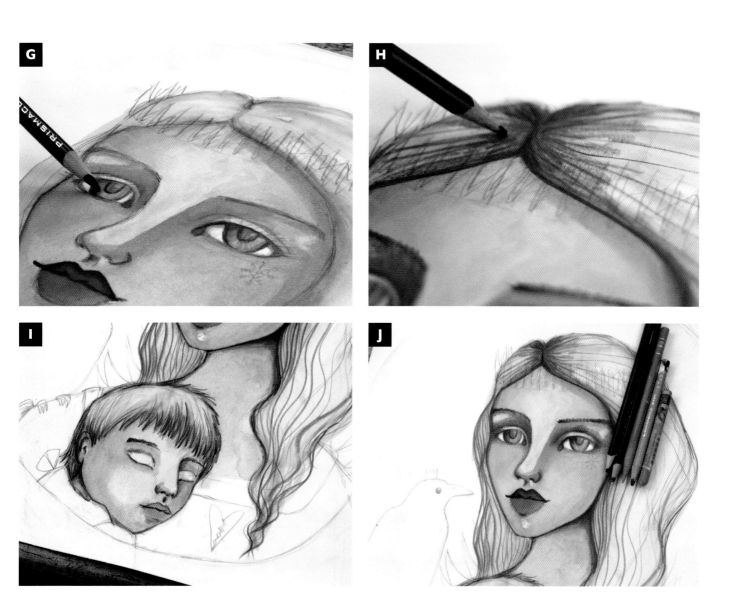

3. Use dark colored pencils to enhance line work and darken the shading in the hair, eyes, and necklines (**G, H, I & J**).

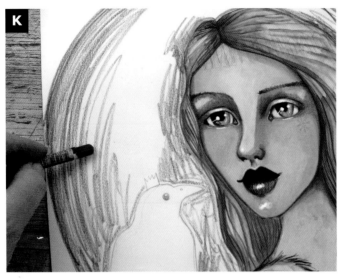

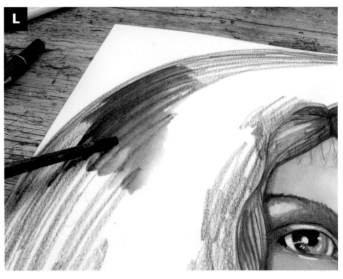

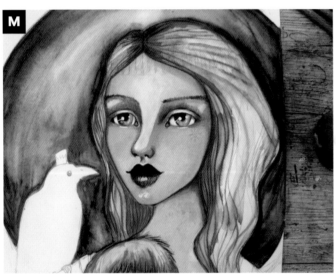

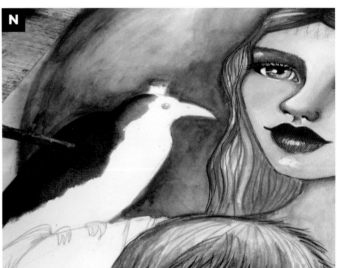

Develop the Background Elements

1. Sketch in a moon-like circle behind the Snow Queen. (You'll later fill this in with the ice-like shapes.) Within the circle, apply a layer of water-soluble crayon in indigo, and then activate it with a damp brush (**K, L, & M**).

2. Paint the crow in black to create mostly a silhouette. He's only there to signal a dark-theme, and I found him more powerful without details (**N & O**).

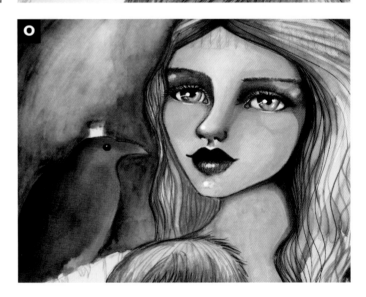

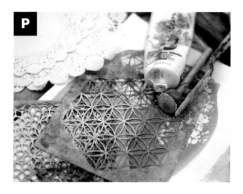

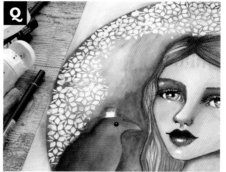

3. Choose some stencils with ice- or snowflake-like shapes. Using white acrylics mixed with molding paste and a palette knife, layer the stencil shapes over the indigo moon (**P & Q**).

4. Using the same indigo as the moon, add color to the Snow Queen's robe. Add a suggestion of a crown and sparkles to the hair in white (**R**).

5. To create a snowy night sky, I painted the corners/background black and then added white snowflakes with paint marker and a white crayon (**S & T**).

Add Finishing Touches

I added my usual meaningful symbols where I felt I needed them. I aslo decided to add a frilly doily to the Snow Queen's robe because the patterns and shapes reminded me of snowflakes and ice. I also added a snowflake doodle to the Snow Queen's face to emphasize that she is, indeed, the Snow Queen (**U & V**).

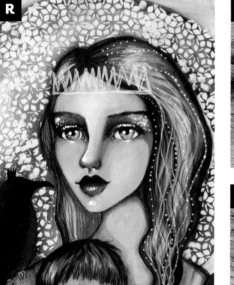

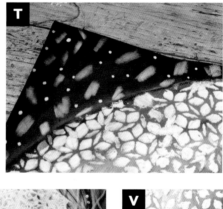

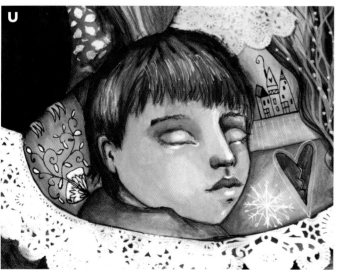

Mulan

Guest Teacher Lucy Chen

Meet
Lucy Chen

Lucy's artwork is so very striking to me. I'm impressed by her portraits, which display subtle emotions and nuances. Each character she paints seems to have a lifetime of story, which you want to learn more about as you take in each paint stroke. For this lesson, Lucy works with the story of "Mulan."

THE ORIGINAL STORY OF "HUA MULAN" was told in an ancient Chinese folk song. Although the name of the original author has long been lost, the story itself was so inspiring that not only has it been one of the most well-known stories in China, but it has touched more and more people in foreign cultures, too.

The story was set in the war-ridden Northern Dynasties time in ancient China, which is around 386–581 CE. Every family was required to contribute one man to join the emperor's army against invaders, and, having no sons, Mulan's father was required to go to war despite his old age and weakened health.

But the young Mulan decided to disguise herself as a man to take her father's place and she set off.

For twelve years, Mulan fought on the battleground as a man. She was a strong warrior, and her leadership and inspiring spirit saw her rise through the ranks to become a general who led her army to win many battles.

When the war was finally won, the emperor asked what Mulan wanted for a reward. Her answer was to go home to live an ordinary life with her family.

Finally, Mulan took off her armor and put on her old dress and walked outside as a woman.

My Thought Process

Having grown up in China, I'm quite familiar with the story. The lyrics of the original folk song was a compulsory subject in school, and I've seen a quite few different adaptations of the story in animation and movies. My feelings about the story depend on how the story was told, and my own state of growth and awareness.

When I first learned about Mulan as a primary school student, I felt it was a lesson on obedience and devotion to your parents and what it means to be a good child—the willingness and courage to sacrifice everything that you have and you are for your parent and to ask nothing in return.

Now when I tap into the spirit of Mulan, I feel that the story is calling me to practice embodying both the divine masculine and the divine feminine within my life. As a woman, we can be as strong and as tactical as any man, and we can be flexible and soft.

I feel that through the story of Mulan and doing this lesson, a doorway is open to show me the possibility of being able to dance in both the masculine and the feminine.

What I Wanted to Bring to the Story

Self-portraiture makes up a big part of my work because it's an intimate and empowering avenue for me to learn about myself and to celebrate my spiritual and personal journey. As this lesson about Mulan is for me about opening oneself to embody both the divine masculine and the divine feminine within, the portrait is a stylized version of my own face.

Mulan's armor and firm stance represent her masculinity and the spear her strength. The flowers represent her femininity, her softness, and the underlying truth of who she is, what she longs for, below the surface of her appearance.

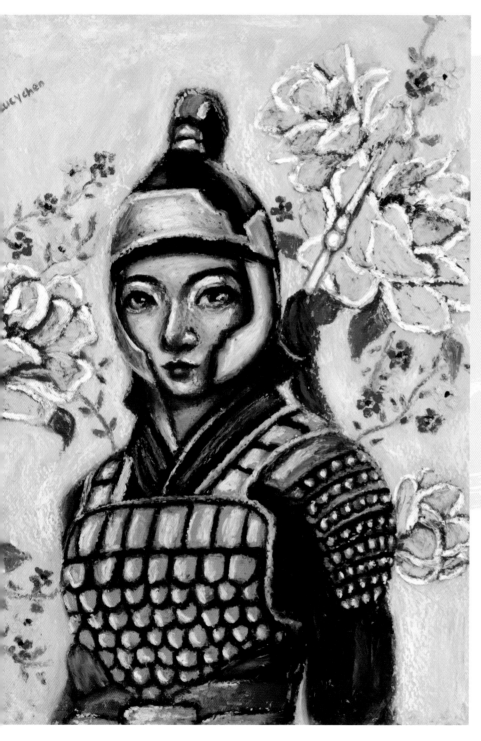

LUCY'S TIPS FOR DEVELOPING YOUR OWN STYLE

- *Make lots of work.* Your style will come naturally just by drawing and painting.
- *Explore a wide range of styles and expand your techniques and skills.* Not only will this help you become a more knowledgeable and skillful artist, but it's also fun to see how far you can push and still have your work be "yours" when you're more established.
- *Work on your personal growth or spiritual practice.* It can be a meditation practice, a shamanic practice, a magical practice, reading books, or anything. But the more you "know thyself," the more your style and the subject matters that matter to you will come through.

Sketch the Design; Prepare the Paper

1. Sketch out the design. If needed, make a preliminary sketch on a smaller piece of paper to map out the composition. Pay attention to the proportions. Alternatively, if you're comfortable doing so, make the drawing directly on your watercolor paper (**A**).

A NOTE ON THE FEATURED MEDIUM

The artwork in this lesson was created with oil-based crayons/pastels, which may pose a bit of a challenge, but since this chapter is about stepping outside of your comfort zone, I encourage you to try anyway! If you don't have these crayons and would rather work with supplies you have on hand, you could attempt this lesson with either water-soluble wax crayons and smudge with a blending stump, Q-tip, or fingers or work with other mediums like acrylics, but you won't achieve the exact same effect and some of the instructions may not transfer exactly.

Art Supplies

- *Oil pastels*
- *Paper stump*
- *HG graphite pencil*
- *Eraser*
- *Synthetic brush*
- *Odorless mineral spirits (OMS)*
- *Heavyweight watercolor paper (I used A3 size, similar to tabloid/11 × 17 inch [28 × 43 cm].)*
- *Acrylic gesso or matte medium*

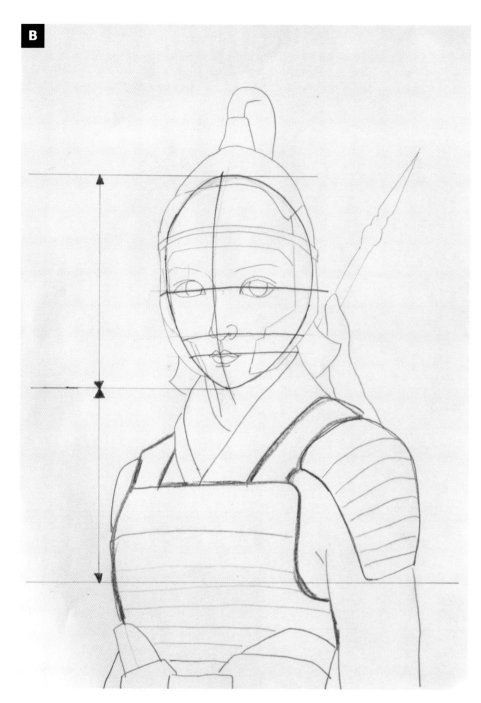

2. There are two ways to prepare your paper for oil pastel paintings. The first option is to apply a layer of acrylic gesso on the paper, let it dry, and then draw on top. The second is to make the drawing first and then apply a layer of matte medium over the drawing to seal the paper. The second option is best if you erase a lot because drawing on a gessoed ground can leave more marks. In both cases, you can use the grid method to transfer your sketch onto your paper for painting. The grid method involves drawing a grid over your sketch and then drawing the same grid of equal ratio on your paper for painting. The important thing is to make sure that the grids have a 1:1 ratio; otherwise your outcome will be distorted. When you draw the image on your working paper, focus on copying the drawing from your sketch one square at a time until the entire image has been transferred (**B**).

Fill in the Details

1. While the concept sketch deals with the general idea, composition, and big shapes, take some time to add the elements of flowers in the background and the texture in the armor in the final drawing. It is easy to make changes at this stage, before the painting starts (**C**).

2. Use a light blue oil pastel to cover the entire background, a black or dark brown to trace the contours of the face and armor, and a dark blue to block in some of the shadow areas (**D**).

Dissolve the Paint

1. Dip your synthetic brush in a bit of odorless mineral spirit (OMS). Starting with the background, brush it over the paper. This dissolves the oil pastel, spreads it around, and covers the valleys in the paper (**E**).

2. Again with a brush dipped in a bit of OMS, trace the oil pastel contours. This will again dissolve the oil pastel, darken the color, and sink the paint into the valleys of the paper. Once you've traced all the contours with a bit of OMS, move the paint into the armor and face to give them each a light wash of color. Make sure not to smudge your contour drawing (**F**).

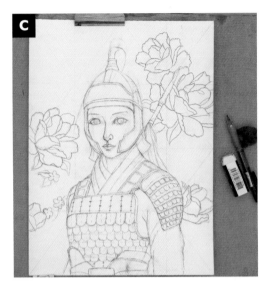

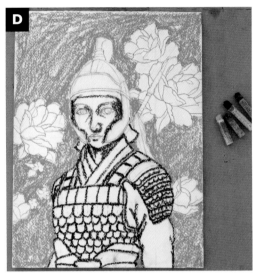

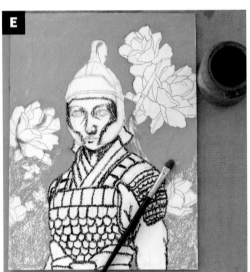

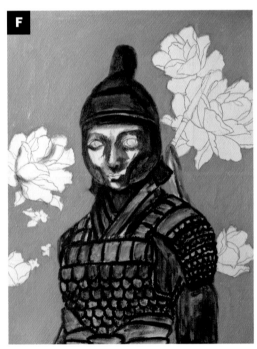

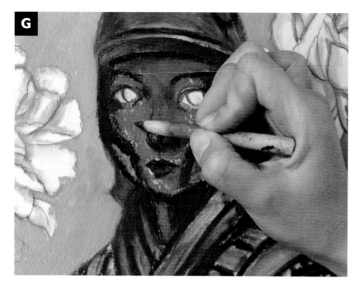

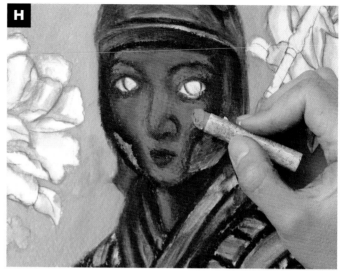

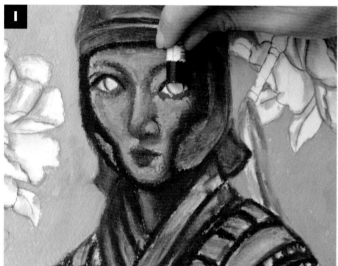

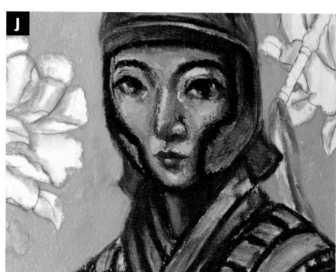

Begin the Face and Armor; Develop the Face

1. Start painting the face with an initial layer of darker and more saturated colors. I used blue, red, and yellow ochre. Use a paper stump to roughly blend and smooth the paint. It doesn't have to be perfect. This will naturally happen when we apply more layers of pastel (**G**).

2. Cover the face with a light peach color. If your oil pastel is too stiff, you may want to warm it up a bit so it's soft but not too soft. You should be able to glide the paint on top but also still have the firmness of a blending stick (**H**).

3. With an off-white yellow or peach color, but not white, repeat the last step, leaving out areas where you want darker tones, such as the shadows (**I**).

4. With black, blue, pink, and white, define the details of the eyes, nose, and lips (**J**).

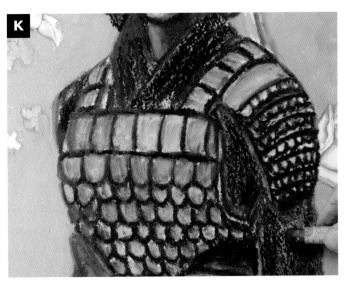

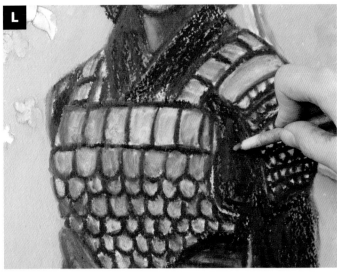

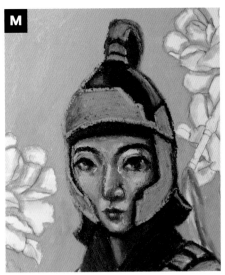

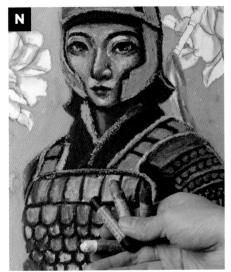

Paint the Armor

1. Cover the shirt under the armor with dark blue and black, in a loose and random way (**K**).

2. Use a paper stump to blend the blue and the black. You don't need a perfect consistency of the same color for the whole shirt; variety is preferred. But make sure the valleys in the paper are filled so there are no white dots (**L**).

3. Give the top area of the helmet another layer of dark blue and the light area a layer of light gray. The light blue used for the background can be applied here to suggest reflected light on the helmet (**M**).

4. The colors for the amor and helmet are black, dark blue, light gray, and white. Refine the drawing with black and dark blue if necessary, and then cover each individual plate in the armor with gray. Use your fingers or a paper stump to blend. Add highlights with white (**N**).

5. With red, paint the belt. This is the red we've used on her face and lips and will use for the flowers in the background. A bit more red in the body will help make the piece coherent (**O**).

Add Layers

1. Use an off-white yellow to cover the entire background. You can use the brush and a bit of OMS to give it a smoother look, leave the texture as is, or a combination of both. This step lightens the background, desaturates the background color to enable the character to stand out more, and provides a more interesting texture (**P**).

2. With red, trace the contours of the flowers and use a brush dipped in OMS to dissolve the drawing and move the paint around gently into the flowers (**Q**).

3. Use a light pink to cover the petals, leaving some darker red untouched as the space between the petals. Use white to add highlights. Once the big flowers are painted, add your own smaller flowers and design your own motif with red, pink, white, and even green (**R**).

Add Highlights & Finishing Touches

1. Use white to add highlights to your painting. This includes the armor, helmet, and Mulan's face (**S**).

2. To add the spear, use the sharper edge of the oil pastel to draw the straight contour. Cover the spear with gray and then add white as highlights. Finally, use red to add the embellishment (**T**).

Goldilocks & the Three Bears

"GOLDILOCKS AND THE THREE BEARS" was written in the nineteenth century by Robert Southey (1774–1843). The story is about a little blonde-haired girl named Goldilocks who enters the home of three bears while they are away. She sits in their chairs, eats some of their porridge, and falls asleep in one of their beds. When the bears come back home and discover her, she wakes up, jumps from the window, and is never seen again.

My Thought Process

Exploring the story, I learned that the original was intended to "warn" children about the dangers of "straying too far away from home," and it also looked to instill an aversion against "stealing" (or using other people's things without permission). Another interpretation is about a girl dealing with the struggles of entering adolescence.

In the original story, Goldilocks was an old lady whom the bears found in their house. Upon discovery, she tried to run away and broke her neck in the process! As with most old tales, they often feel devoid of empathy and focus on moralistic lessons. Though I love many of the old tales and wisdom can be gleaned from them, they rarely look more deeply into the characters' stories and backgrounds. That frustrates me, and it's something I enjoy bringing to stories myself, if at all possible.

What I Wanted to Bring to the Story

I wanted to reimagine the story of "Goldilocks and the Three Bears" to include bears that respond in a compassionate way rather than being angry and upset about finding a lost girl in their house who used their personal possessions.

I chose to paint Goldilocks sleeping in the bed surrounded by bears towering over her, but I wanted them to feel like benevolent protectors or guardian angels instead of menacing/angry beings.

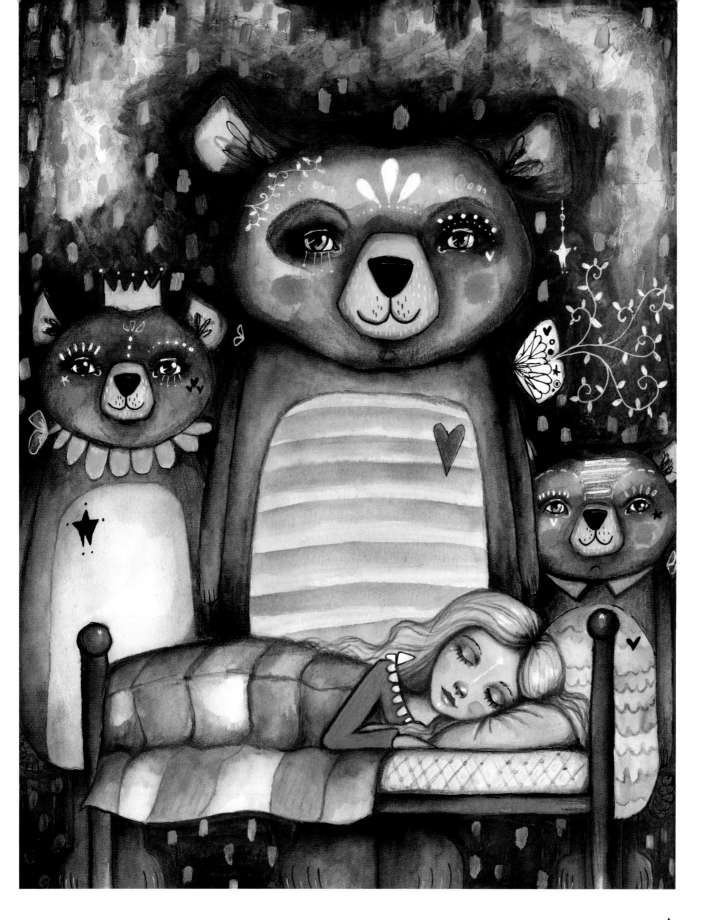

Draw the Design

Draw/sketch Goldilocks and the bears (**A & B**).

Add Color to the Bears & Goldilocks

1. Paint the bears' faces with water-soluble crayons and watercolor paints in browns (**C**).

2. Use darker browns to add shading (**D**).

3. Add color to the bears' muzzles and cheeks with water-soluble crayons and watercolor paints. Let dry. With paint markers, add doodles in black and white to the bears' faces and ears (**E**).

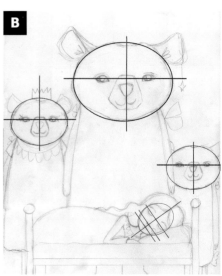

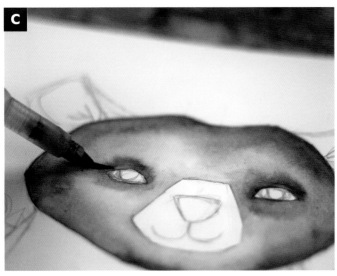

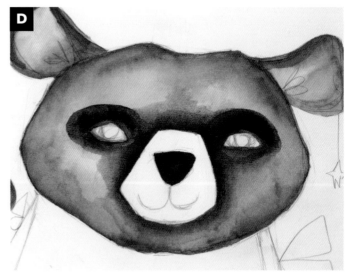

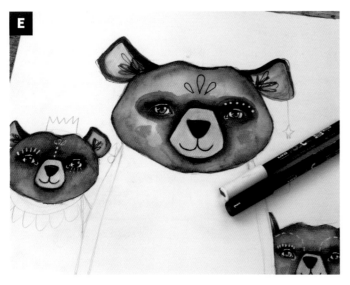

4. To block in Goldilocks's hair, I used markers in a couple of shades of yellow. For her Caucasian skin, I started with a salmon tone, which can be created with either water-soluble crayons or watercolor paints (**F**). (See page 20 for advice on how to start darker skin tones.)

5. Build up darker shading and add details to the face with crayons, colored pencils, and markers. Add highlights with a white paint pen (**G**).

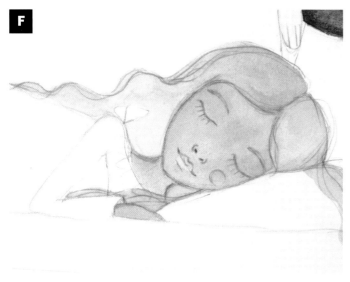

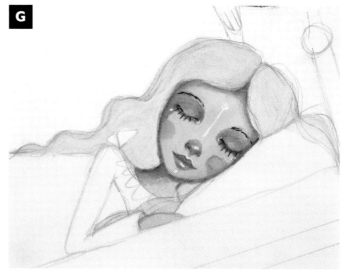

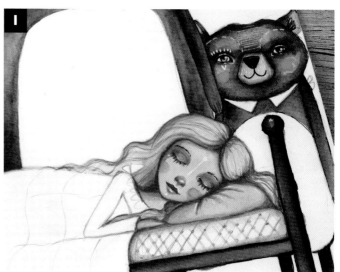

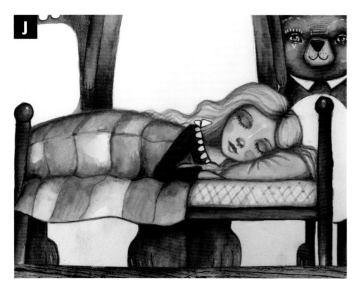

Develop the Details

1. I wanted to do something "fun" on the bears' tummies, so I left them white for the time being and finished the surrounding areas with the same brown paints I used for their faces (**H**).

2. I used markers to add shading and detail to Goldilocks's hair, as well as to the pillow and mattress (**I**).

3. I made the blanket checked and in blue tones (which go well with browns) using a mix of water-soluble crayons and watercolor paints. I also added a deep pink to Goldilocks's dress (**J**).

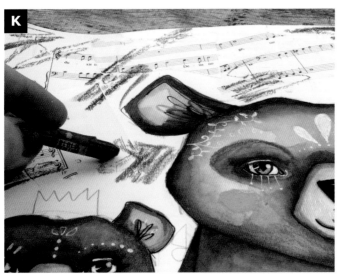

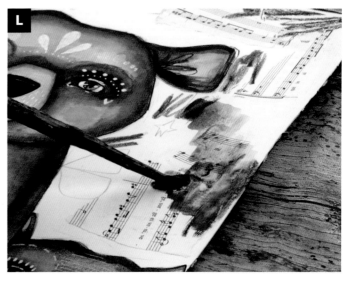

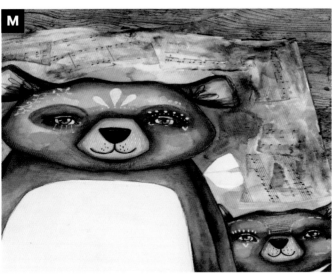

Create the Background

1. For the background, add one layer of collage and then a fairly intense layer of water-soluble crayon in indigo to create a night-time background (**K, L & M**).

2. To bring unity and cohesion to the background, add white gesso over this layer with a dry-to-damp brush for texture (**N**).

3. For contrast, I brought back the indigo crayon to create an "aura" around the bears (**O**).

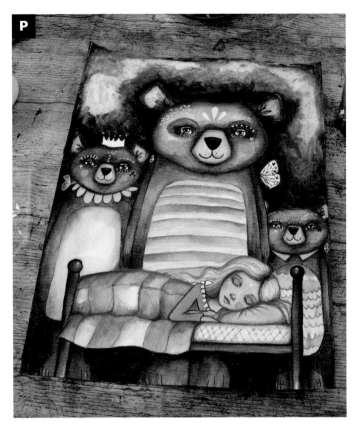

Add Finishing Touches

1. I added bright, playful colors to the bears' tummies—one has stripes, another has scallops—so they come across as peaceful and kind (**P**).

2. I also added doodles and colorful elements to the bears and the background, to liven the piece up a bit and to further emphasize the idea that the bears have come as guardians/kind benevolent beings to watch over Goldilocks while she sleeps (**Q**, **R** & **S**).

Blodeuwedd

Guest Teacher Effy Wild

Meet Effy Wild

Effy is a treasured friend and colleague who's a master at diving deep, sitting in her emotional fire, facing up to what's needed, and meeting herself (including all her raw parts) on the page. Effy's work often incorporates deep jewel tones that give rise to a sense of depth and mystery. Here she explores the story of "Blodeuwedd."

FOR THIS LESSON, I WORKED WITH the Welsh legend of "Blodeuwedd" (sounds like *blu-dye-a-weeth*), whose story goes like this:

Blodeuwedd (which means "flower face" or "owl") was created by the sorcerer Math out of the flowers of the earth so that Llew, who was cursed never to marry a mortal woman, might have a wife. Without marrying, Llew couldn't attain kingship, so his friends helped him break this curse so he might become king.

One day, Blodeuwedd, who had never been asked to consent to her marriage to Llew, caught sight of a hunter in the forest and fell instantly in love. Her feelings were reciprocated, and she and her lover, Gronw, conspired to remove Llew from the equation by killing him. Due to a protective spell cast upon him by his companions, Llew could only be killed under very specific circumstances: neither in a house nor out of doors, neither in water nor out of it, and only at very specific times. Blodeuwedd feigned anxiety about this, and asked Llew to demonstrate the special circumstances under which he could be killed, telling him that she wouldn't stop worrying until she could see for herself how difficult it was. Llew created all the circumstances necessary, and when he took position, Gronw shot him in the side with an arrow. Llew, being a magical being himself, turned into an eagle and flew away where he could rest and be healed.

Upon his return, Gronw was killed for his treachery, and Blodeuwedd was turned into an owl. Llew, having experienced death and rebirth as a result of Blodeuwedd's actions, now met all the conditions to become king.

My Thought Process

I love this story and especially the character Blodeuwedd because it speaks to the importance of consent. If Llew had asked Blodeuwedd's permission, there may have been an opportunity for love between them, instead of the treachery and tragedy that followed. There's also a deeper meaning in this story about how even when things go terribly awry, there's potential for good things to follow. In truth, had Llew not experienced what he did, he would never have been fit to become sovereign, and though it sounds like a terrible thing to be turned to an owl, the owl is a figure of great wisdom and mystery in Celtic lore.

What I Wanted to Bring to This Story

The story of Blodeuwedd seems to be about a woman who is faithless and treacherous. When we go deeper into the story, we realize that she was created of flowers and of the earth itself. Therefore, she was never subject to be given as wife to Lleu to begin with, and Lleu could never have reigned without the experience he had with her—that of being sent to the underworld and then being transformed and resurrected.

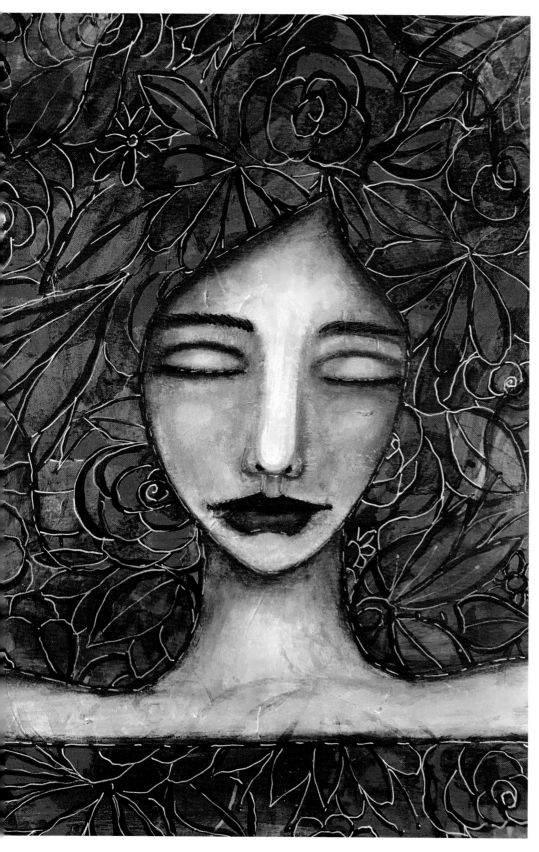

I wanted to honor Blodeuwedd's sovereignty and power to choose. I wanted to have her front and center, not as a side character in the story but as the main character—the catalyst for the transformation that took place and allowed Lleu to come into his full power. I also wanted to remind the viewer that Blodeuwedd was not just simply a woman created out of flowers. She was the living, breathing embodiment of the Goddess Herself in full control of the story, even when it didn't seem so. This deeper understanding of the story allows us, as women, to encounter the power of our own choices, and I find that very empowering.

Create the Underpainting

1. Begin with a selection of acrylic paints—iridescent, fluorescent, and matte—in warm colors. Scrape these all over the paper with a palette knife, leaving some areas blank (**A**).

2. Once dry, repeat with a selection of iridescent and matte paints in cool colors, adding them here and there until your paper is covered in color. If you want, you can let this layer dry and keep going, alternating warms and cools until you're happy (**B**).

3. Use a dark fluid acrylic (I used Payne's grey) to paint-doodle florals all over the page. Vary the shapes of the flowers so that what you're left with is a kind of close-up of a garden (**C**).

Sketch & Block in Blodeuwedd

1. Once your background is covered in florals and they're completely dry, use a white STABILO All pencil to sketch in the basic shape of Blodeuwedd's head, hair, neck, shoulders, and a simple garment (**D**).

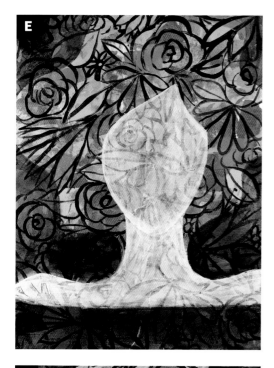

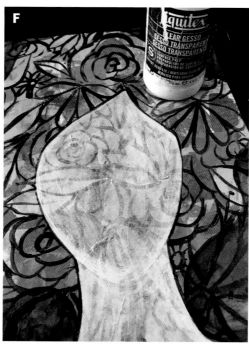

2. Add a thin layer of titanium buff paint to the face, neck, and shoulders. Keep it thin enough so that some of the floral outlines show through. Add a transparent layer of a deep turquoise over the florals in the background to create the outline of Blodeuwedd's hair and a rich magenta to her garment (**E**). Let dry.

3. Wipe off any remaining STABILO All Pencil with a damp paper towel or baby wipe. To make the next few layers easier, apply a layer of clear gesso and let dry (**F**).

Develop the Face & Features

1. Use a graphite pencil to sketch in Blodeuwedd's eyes, eyebrows, nose, and mouth. I depicted my figure with closed eyes. (**G**).

2. Add shading with the pencil and blend it out with a paper blending stump until you're happy with the result. Once you're done with this layer, spray it with workable fixative to prevent the pencil from smearing (**H**).

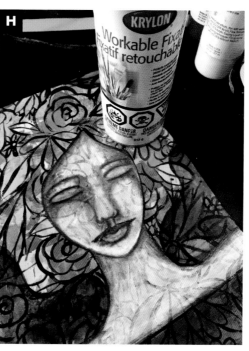

3. Use India ink markers (my favorite are Faber-Castell) to add color to the fixed pencil layer. I used two shades, a medium pink and a reddish brown. Faber-Castell markers have an extended drying time, so you can work them around a bit with your fingertip. If you don't have these markers, use paint on this layer instead. Keep your layers thin (**I**).

4. Mix a bit of magenta with titanium buff to create a Caucasian flesh tone and scrub that in a thin layer, layering paint with more of the reddish brown marker, drying between layers to build up Blodeuwedd's face, neck, and shoulders. Layer the paint with the smoothed-out markers until you're satisfied. I also added marker to her lips (**J**).

Refine the Hair & Face; Add Highlights & Finishing Touches

1. Add a layer of transparent burnt orange to the hair to make her feel more "earthy." While that dries, use fine-tip white and black paint pens to outline the florals in the background and the garment and to add some broken white outlines around the face and hair, which I also used this in the eyelids to light them up a bit. I added a bit of black paint pen around her lash line, in her nostrils, and in the line between her upper and lower lip (**K**).

2. Use a broader-tipped white Uni-Posca paint pen and a paint brush to add highlights to the nose, chin, cheekbones, forehead, and eyelids. Add a bit of paint with the paint pen and then distribute and smooth it out with a paint brush. I lightened her lower lip with the same method (**L**).

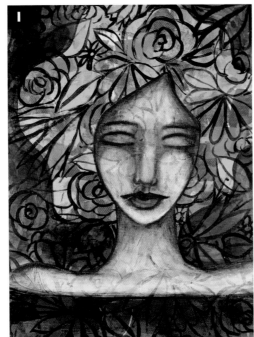

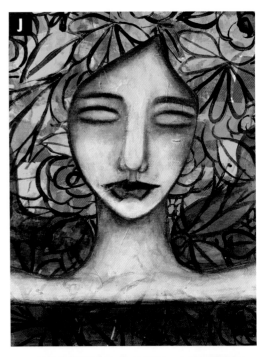

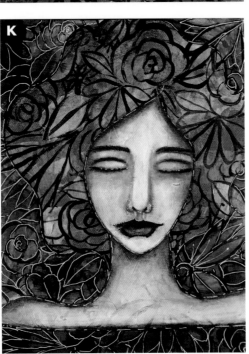

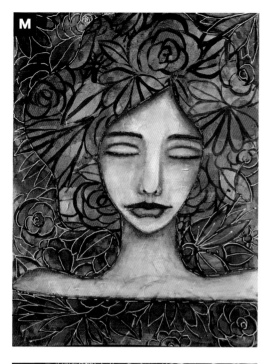

3. I worked on the face a bit more by layering more titanium buff and reddish brown marker until I was satisfied. I also added a thin layer of magenta to her hair since I wasn't loving the burnt orange and wanted to pink it up a bit (**M**).

4. To warm up her face, add some magenta, especially to her cheeks and lips. Add a few soft highlights to the tip and bridge of her nose and her forehead (**N**).

5. I realized that I wanted the same white outline in the hair as I'd added to the background, so I did that using a white paint pen (**O**).

6. I added a layer of Faber-Castell marker in a turquoise color over the white paint outline in the background to push that back a bit (**P**). Finish your painting with a sprayed gloss varnish to seal and protect it for years to come!

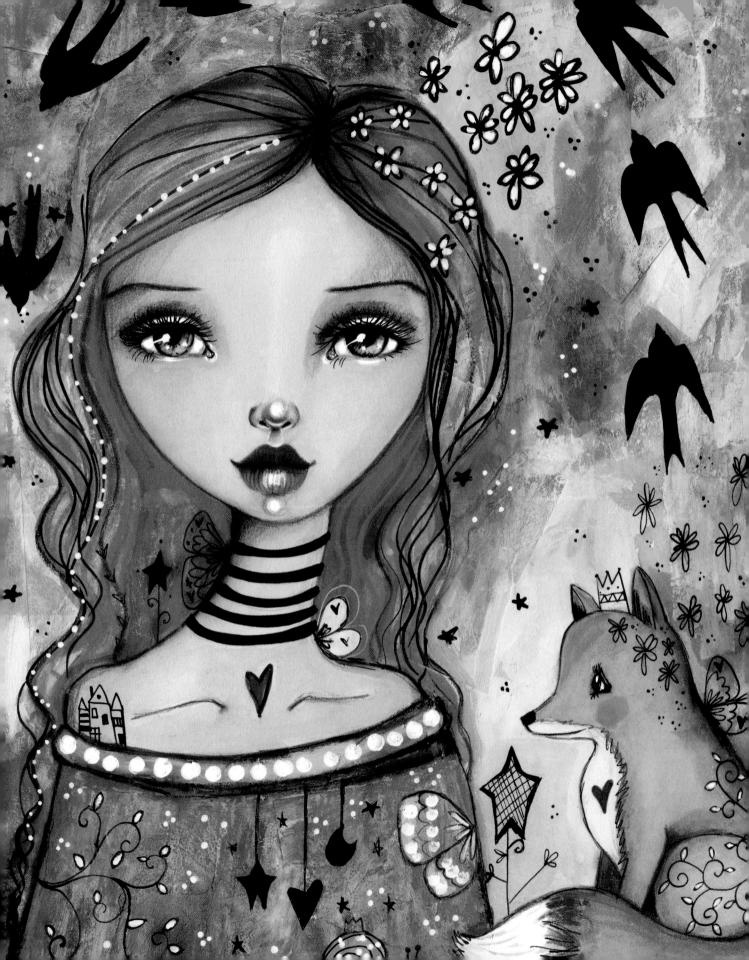

4

Dealing with Challenges & Deepening Your Voice

O N YOUR STYLE DEVELOPMENT JOURNEY, you're bound to bump into challenges that can get you stuck. In this chapter, I want to go over some common hurdles and blocks that can plague the artist.

To stay strong on your style development path, you can look a little more deeply at the things that stifle, stop, or paralyze you. Here I also share some ideas on how to become more self-aware and deal with the common blocks and issues artists face.

Starting a Mindfulness Practice

Many people aren't always aware of why we're unable to move forward with our creative practice. A variety of things can be happening. One thing I encourage you to start doing (if you're not already) is to pay closer attention to what is going on in your mind, in your heart, and in your soul. Consider a mindfulness practice to help with more inner awareness.

A mindfulness practice will increase your self-awareness. Not only can this be healing in itself, but it also will help you find solutions to the obstacles you're facing.

Let's start by looking at one of the **biggest obstacles** many artists face.

Exercise: Facing the (Dreaded) Inner Critic

The inner critic is an internalized (unpleasant, often parental) voice that might comment on your work, who you are, or what you do. This voice may sound something like this:

- "Who are you to think you can create anything beautiful?"
- "Making art is a terrible use of your time!"
- "That doesn't look like a face. Please stop this."
- "The colors are mud, nothing goes together—this is awful."
- "If you can't paint pretty pictures, you're clearly unworthy."
- "You're useless. You can't do anything."
- "Who are you kidding with this? Just stop already."

A loud inner critic can depress some of us and stop us from creating or moving forward. So how do we deal with the inner judgment and the feelings of hopelessness, depression, and disappointment that follow? Here are some ideas.

- **Understand the inner critic's purpose, her drives and motivation.** From my own personal therapy, I know the heavy judgments are often an attempt at stopping further hurt. She's using painful methods to get you to hurt less! Odd, isn't it? This is because she comes from a place of fear. Understanding this and having real empathy for the inner critic and her motives, often helps me move beyond the judgments to a place of abundance and joy. It's not easy and can take real bravery and courage. But it works.
 » QUESTION: *What motivates your inner critic to say the things it does?*

- **Reframe your thinking.** Allow, accept, and celebrate mistakes and messes! As with learning to walk, drive, learning a new language, and becoming a brain surgeon, you first have to learn the basics. As part of this learning process, you have to make mistakes to understand what works and what doesn't.

 I'm not saying accept mistakes or be okay with mistakes. I am saying you *have* to make them. If you don't make mistakes, you'll actually learn a lot less. So give yourself the freedom to make glorious, amazing, beautiful mistakes and messes, and celebrate them! Indeed, you can even see mistakes not as mistakes at all but just as "learning experiences" and opportunities for growth. Scientist and inventor Thomas Edison offered the brilliant response below when he was asked how he felt about having failed so many times before inventing the light bulb.

 » QUESTION: *How can you reframe "messes and mistakes"? Try some reframes for yourself.*

- **Give yourself time.** Explain to your inner critic how it takes time to develop your skill and style. Ask her kindly for that space and time. It may take a baby a year or more to walk. You don't tell it to stop or how terrible it is at walking after a few weeks! You give it the gift of time. Very few people make a masterpiece when they first pick up a paintbrush. Most people who paint pictures you enjoy worked hard, faced their fears, allowed mistakes to happen, and kept going.

- **Examine what you're doing it all for.** If you are creating for the approval of others (this is understandable; we all need to be loved and liked), try your hardest to redirect your focus to creating for the sake of creating and what it brings you. *If we're creating for the sake of "other-approval," the inner critic is usually a lot louder because there's a lot at stake.* If you create simply because it lights up your heart, the inner critic is less worried. So

try to create for the joy of it, enjoy the process and be less concerned with gaining other people's approval.

» QUESTION: *Why are you creating? What are you doing it all for? Take a moment to write it down.*

- **Don't equate your self-worth to your abilities/ skills.** You're perfectly whole. You're worthy and good enough just as you are. Your worth doesn't increase if you make amazing paintings, nor does it decrease if your paintings don't impress anyone. There's no relationship between your worthiness and your abilities to create a nice painting. None. Zilch relationship there. Be *very* clear to point this out to your critic (and to your family and teachers!). If you think your worth is dependent on your skills and abilities, your inner critic will be terrified of making a "bad painting" because "bad painting" means "bad you." That's total nonsense. But sit with that one for a bit. Many of us have this "abilities = worthiness" confusion. It took me years (and I'm still working through it now) to not equate my skills/abilities to my worthiness. By realizing that you're still lovable and good enough no matter what you create, you can create much more freely.

"I have not failed. I've just found 10,000 ways that won't work."
—THOMAS EDISON
(1847–1931)

- Lower your expectations. **Don't start out by thinking you'll make a "masterpiece."** This expectation can paralyze. Even if you manage to get going, your inner critic will be watching over your shoulder, stifling your creativity and your courage to explore. Your brushstrokes or marks will feel forced and rigid, all their playfulness lost. Lowering expectations helps you to breathe, explore, and be free, with a higher likelihood of producing a painting you value. Allow play to be your source of inspiration, rather than a wish to create a "perfect" painting. Enjoy the journey.
- **Focus on the creative journey, not the end result.** I *love* it when I make a painting I adore! *But*, if I start with the intention of making an amazing painting, I often don't enjoy the process. I want to rush through it and I miss the creative journey. It's all about being on the creative journey. And guess what? If you allow yourself to be free and enjoy the journey, you're more likely to end up creating something you like (though that's *not* the focus!).

> **"If you hear a voice within you say 'you cannot paint,' then by all means paint, and that voice will be silenced."**
> —VINCENT VAN GOGH
> (1853–1890)

Exercise: Dealing with Outer Critics

Like the inner critic, outer critics can also be very judgmental. And, oh my, doesn't the inner critic *love* outer critics! The inner critic loves it when she can say, "*I told you so*." So how can we protect ourselves from the impact of criticism?

- **Don't trust the opinions of friends and family.** While there might be the odd family member or friend who can give you unbiased, neutral feedback, most are too close to do so. My family and friends often give me feedback that is either overly positive (to "big me up" or to avoid hurting me) or overly negative (maybe to give "life lessons" or "tough love"). It's best to take any feedback from family and friends with a pinch of salt.
- **Don't take infrequent, extremely negative criticism personally.** Such criticism is likely about *them*, speaking from a place of their own pain or from being triggered. It's not about *you or your work*. Though the words may hurt and upset you, try to feel reassured that extreme responses are rarely neutral and therefore less reliable.

 Learn to distinguish between helpful constructive feedback and "someone being triggered into their stuff."
- **Learn from those with experience dealing with critics.** Sometimes, when inner and outer critics overwhelm me, I find it helpful to seek out people with great ideas for dealing with critics. One such person, author Brené Brown, has a very powerful talk titled, "Why Your Critics Aren't the Ones Who Count." Search for it and listen to it. I love how she filters out the kind of feedback she welcomes and the kind she doesn't. She sets clear boundaries we can all learn from.

- **Learn that we're all different,** with different tastes, and that your painting isn't *you*. It's hard to hear that you're simply not someone's cup of tea! But remember that everyone comes with their own history. Whether your work is liked or not will be highly influenced by everything that person has lived through. It's not your responsibility if your art doesn't resonate with someone. Separate this out. Break it apart. There might be a thousand reasons why someone might not like your painting. None has to do with the painting being good or not or whether you're good or not. So distinguishing between you, your product, and the other person will help you find more acceptance all around. Learn to embrace our differences and incompatibilities.

- **Find your tribe and set boundaries.** Consider finding places where you trust the people and their conversations. Maybe avoid those where you might get heavy criticism. I used to submit photographs to a site where people rated them and gave critical feedback. It made me miserable and stressed so I stopped going there. Instead, I found a space online where I knew that most people would respond in ways that I enjoyed.

Sometimes I set boundaries by: (1) not allowing comments; (2) specifically saying, *"I'm not looking for advice here;"* or (3) inviting a positive, compassionate atmosphere. I also aim to walk the walk: If I don't enjoy receiving negative feedback or advice on my art, I don't give it out, either.

- **Don't respond to criticism from a place of anger** if you can help it. Try not to react or reply right away. Take your time, talk it through with someone, breathe through your "stuff," and then *try* to respond with empathy and compassion— as hard as that may sound! If you respond from a place of anger, you may say something defensive, possibly offensive, that can create just a big, hard-to-resolve mess, especially when you're not face to face. Do this also because it will contribute to world peace (I'm serious!); disarm and surprise your critic—and show them what compassion *is*. It will support your business and it won't tarnish your reputation.

- **Learn to be open to criticism if you want to license your work.** A commercial artist, licensed by manufacturing companies, needs to be open to constructive feedback. While staying aligned to your bliss and personal truth will imbue your work with beauty and aliveness, you may need to change topics, themes, and styles to suit the current market needs.

- **Get to you know your triggers and put protective systems in place** to help you process them or protect you from them in the first place. For instance, you can ask an assistant to read through survey comments and weed out any likely to upset you.

Deepening Your Voice, Story & Style

"Style development" isn't "sticking to one style only." Evolution of your style or changes in your work never stops!

Many of the great masters' styles evolved over the course of their careers. See the examples below of early and later works by Pablo Picasso.

With your style established, let it continue to develop by having space and opportunity to follow your truth. Don't worry about fitting into a box or framework. The more life experiences you have and the more inspiration comes to you, the more your style is likely to blossom, grow, and evolve. Allow it to happen.

Changes in style are often incremental. You'll find yourself subtly wanting to modify or change as you go through life. For instance, I moved to a new home two years ago. The swallows that visit every summer inspired me and now show up more in my work. While this doesn't particularly denote radical style changes, should I use the swallow more frequently and in a repetitive, recognizable way, it could become a signature element of "my style." (Turn to page 110 to see the entire piece.)

Details of postage stamps featuring Picasso's work that show a striking contrast in style. Left: *Yo Picasso* (self-portrait), c. 1901. Right: *The Piano*, 1957.

Something that's a signature part of my style (for now anyway!) is butterfly wings, and yet they continue to evolve. The wing shapes, once quite realistic, are now more whimsical, and recently I've added third and fourth wing segments plus extra doodles and decorations.

Continue to bring in "the thing that lights you up." Follow what "inspires you" and bring it into your work. If you keep landing back into your truth and heart space, the sun will *shine* from your paintings.

In summary, allow yourself the joy of evolving your story, your message, yourself, and your style. Continue to land back into your heart space and stay aligned with your values, bliss, and joy, and your paintings will shine your with beauty and authenticity.

WAYS IN WHICH A STYLE COULD EVOLVE

- *New color schemes.*
- *New themes/subjects/objects.*
- *New art supplies/materials changing the look of your work.*
- *New doodles/meaningful symbolism.*
- *Existing doodles/shapes themes may evolve into a new/different thing.*

Peter Pan

"**PETER PAN**," or "The Boy Who Wouldn't Grow Up," is a story written by J. M. Barrie (1860–1937). One of his most famous works, it was first created as a play and then later published in a novel. The character of Peter Pan first appeared in one of Barrie's earlier novels, *The Little White Bird*.

The story is about a boy, Peter Pan, who can fly and doesn't want to grow up. He lives in a place called Neverland, where he has lots of adventures involving pirates, fairies, mermaids, and other fantastical creatures.

Peter Pan visits the Darling family one night and persuades Wendy Darling (the oldest of three siblings) to come with him to Neverland so she can become mother to his group of Lost Boys. Wendy's brothers also come along.

After several adventures in Neverland, Wendy returns home with the Lost Boys, to the sadness and anger of Peter Pan. Wendy's mother decides to adopt the Lost Boys and Peter Pan, but he refuses because he doesn't want to be "forced to be turned into a man" and returns to Neverland.

My Thought Process

While delving more deeply into this famous story and researching the symbolism, I often came across the idea that Peter Pan didn't want to grow up because he was selfish and wanted to remain the "eternal child," with all the fun, ease, joy, self-centeredness, and playfulness that childhood offers.

Considering that proposition, I contemplated other reasons why Peter Pan might not have wanted to grow up. I thought about the perceived role of "men" in the world (then and now) and how the patriarchy has made it so that "men," in general, are not encouraged to accept/embrace all aspects of themselves, including their more feminine (often judged as "weaker") sides. It is common to believe that *"boys don't cry"* and that *"boys have to be hard or strong."* The patriarchy seems to dictate a particularly one-sided role/behavior of men.

Putting myself in the mind of Peter Pan (or any boy) for that matter, I could completely understand not wanting to "grow up" under such circumstances. Not so much so that I could remain a child, but really to *avoid* the unrealistic and damaging expectations I would have to fulfill as a grown man. I found it particularly poignant to think that Peter Pan's group of boys were called *"The Lost Boys,"* such an apt name for young boys lost in a society that wants only one side of their personalities to flourish when they grow older. Why would a boy want to grow up to be a "man" if he has to disown and reject parts of himself?

I have two young sons and feel very worried about their mental health in today's society. I want them to be able to express and embrace themselves fully, including all the masculine and feminine aspects within them.

What I Wanted to Bring to the Story

I wanted to paint Peter Pan with a wistful, somewhat sad and contemplative expression on his face, looking off into the distance to highlight his trepidation/ambivalence about what's to come should he grow up. I didn't want to emphasize the usual playful side that's often highlighted when Peter Pan is portrayed, but a deeper, more aching part inside of him that anticipates will be rejected should he choose to "grow up."

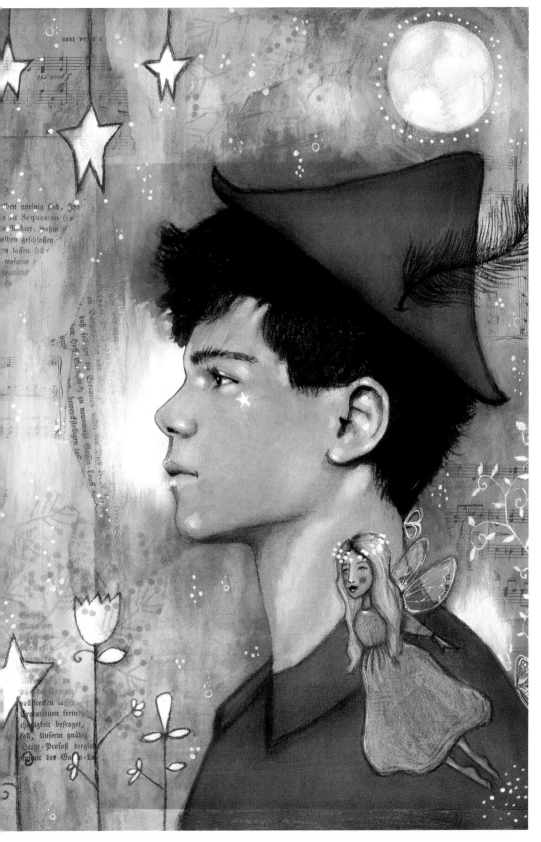

Interestingly, the term *"grow up"* is often used scathingly in response to someone who might express their feelings, as if to say *"get over yourself, do not feel your feelings."* Implying that "grown-ups" should have a hard outer shell and not bother themselves with feelings is a message that I believe is extremely damaging for men, women, and all other genders.

I wanted to include Tinkerbell by his side because although she's the jealous and spirited type, she always comes back to him in a supporting role, which is what I feel Peter Pan (and all human beings) really need—unconditional acceptance and love.

Lastly, I'm including the star shapes that I usually use, but made the middle one larger/brighter to imply "the second star to the right," which is the way to Neverland.

The technique I used for this painting is "paint over collage."

Create the Collage

1. Gather collage materials. For this lesson, I wanted Peter Pan central to the painting, so I looked for a large portrait of a teenage boy with a side profile. You'll also need patterned collage papers like book pages, music scores, and scrapbooking pages (**A**).

2. Lay out and then glue your collage with gel medium. Let dry and then apply a layer of clear gesso so you can create subsequent layers. **Important:** Once your collage is glued and dry, take **a photo of each layer** so you can see it transform. You can also use the photo as a reference if you want to follow the original shading (**B**).

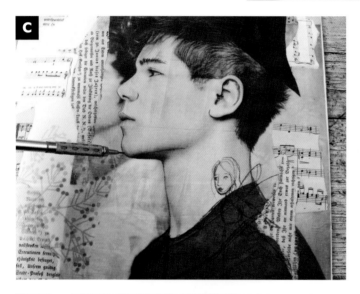

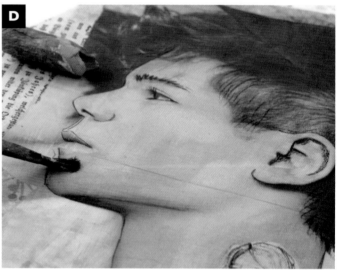

Draw & Paint

1. Draw over your collage. You can change facial features, add hair, add doodles, whatever calls you. This is when I drew the fairy Tinkerbell over Peter's shoulder (**C**).

2. Add paint and color over the collage. I painted Peter's face by starting with a salmon color crayon (**D**). (See page 20 for advice on how to start darker skin tones.)

3. Use lighter acrylic paints for lighter areas (**E**).

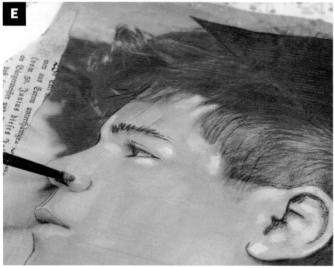

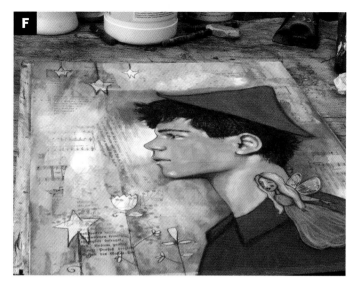

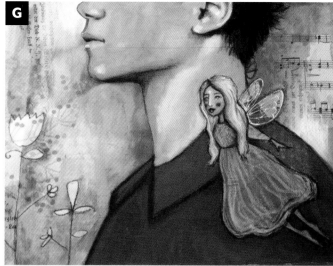

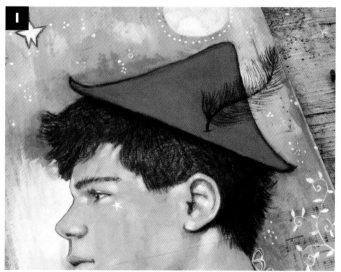

Develop the Background; Add Finishing Touches

1. For the background, I added a light wash of water-soluble crayon in a turquoise. I wanted to keep it serene and simple, to make sure Peter Pan would pop off the page. I also added a simple color to his clothing and hat (the traditional Peter Pan green), but again, I didn't add too many bells and whistles so that Peter really draws you in (**F**).

2. Use colored pencils and crayons to add color to Tinkerbell (**G**).

3. I added a moon and white sparkles to liven up the background while keeping the overall area simple and serene (**H**) and a feather to Peter's Hat (**I**).

4. I gave Tinkerbell her wings and a white sparkle crown (**J**).

Beauty & the Beast

Guest Teacher Mariëlle Stolp

Meet Mariëlle Stolp

Mariëlle's characters are from a magical fairy-tale kingdom— no wonder they mesmerise me so much! They speak of kindness and gentle acceptance. I love her use of color and composition. She works with the story of "Beauty and the Beast" for her lesson.

"BEAUTY AND THE BEAST" is a very well-known fairy-tale. Many versions exist as movies and books that we all grew up with and love. While researching its origins, I discovered that the first known printed version was written by the French author Gabrielle-Suzanne Barbot de Villeneuve (1685–1755) and published in 1740.

I got my hands on a recently published and beautifully illustrated English translation and was in for quite a surprise! Her version doesn't only tell the story of the Beauty and the Beast, but also contains many details about the lives of the Beauty's and the Beasts' parents.

You probably know that Beast is actually a prince, but did you know that he lost his father at a young age and that his mother had to lead her country's army against a neighboring king? And that she left him in the hands of a rather old, ugly, and nasty fairy that fell in love with him and wanted to marry him, and when he refused, she turned him into the Beast?

I was also surprised to find out that, in this version, Beauty is actually the daughter of the King of the Fortunate Island and a fairy. This fairy broke fairy laws by falling in love with a human and not attending to her fairy duties. The Fairy Council then decided that she must remain in "fairy land" and that as extra punishment, her daughter must marry a beast.

The King is unaware of the true story and remains heartbroken while Beauty's aunt—her mother's sister and also a fairy—finds a way to make everything work out. She protects Beauty by placing her in the care of a merchant who lost his daughter, and she places the Beast in a magical castle until both are old enough for her plans to unfold. And no worries—her intricate plans come together! Beauty falls in love with the Beast and, in doing so, she not only saves his life but returns him to his true form. They get married and live happily ever after.

My Thought Process

While reading the story, discovering all the complicated side stories and noticing all the differences of later versions, I decided which characters I wanted to include in my painting. Since drawing sweet, whimsical girls is my first love, Beauty was definitely going to be the main focus, but I also wanted to include the Beast and a talking parrot. Parrots play a big part in this version, as they keep company with Beauty, who—apart from the rather silent Beast— is all alone in the enchanted castle. I also wanted to include orange trees, which are mentioned several times throughout the story and might be inspired by the huge Orangery at Versailles, where Louis XIV collected orange and other trees from across Europe. I placed my scene at night because, in this version, Beauty's dreams play a huge part: the Good Fairy talks to her and she dreams of the handsome and kind Prince.

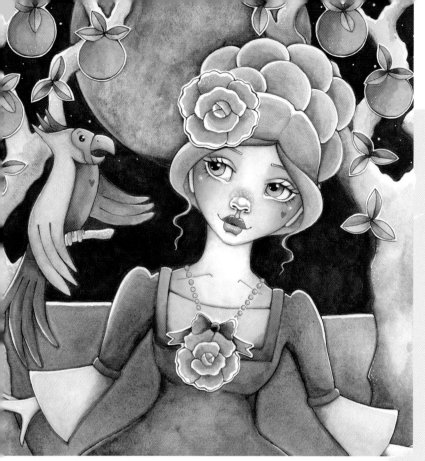

What I Wanted to Bring to the Story

Quite obviously this book contains the message, "Don't judge a book by its cover." If you take a much closer look, another message is: "What's on the inside is what really counts."

What struck me in this version was the feeling that Beauty didn't trust her own instincts and didn't follow her heart because she simply couldn't believe it to be right. I've often been in situations where my head decided that my heart's desire was foolish, unthinkable, unreachable, too ambitious, or not ambitious enough. Maybe I simply worried too much about what other people might think to really listen to my heart. But the truth was always there, carefully hidden.

The importance of the rose—the gift Beauty asked from her father, a symbol of love, youth, joy, and purity—made me remember the term "sub rosa," which literally means "under the rose" and stands for secret, private, confidential. Deep in her heart, Beauty already knows the truth! I decided to work with that idea, creating for her a rose-shaped locket with a little picture of the Beast inside, hanging on her chest, close to her heart.

MARIËLLE'S TIPS FOR DEVELOPING YOUR OWN STYLE

- *If you're serious about developing your own style,* **listen to your heart and trust its whispers.** *The Beast almost died because Beauty didn't trust her feelings, so listen carefully and see where it takes you. In real life this might be scary or even impossible, but when putting paint on paper there's nothing to be afraid of. Nothing is too crazy, too childish, or too ambitious in art! And if you don't like your results, don't throw it out—save it for another day. Maybe a few weeks later, looking at it with fresh eyes, you will actually see that you learned something, made a discovery about yourself or your art, and grew as an artist.*

- *When you're feeling tired, stressed, and overwhelmed,* **relax and restore.** *At times I can feel a bit overwhelmed and drained by our busy, complicated world. To restore my energy and spirit, I need a little escape to a whimsical, uncomplicated fairy-tale world. How do you relax and unwind? Maybe it's music, or nature, or taking a walk with your dog. Can you bring elements of that into your art to make it more personal, meaningful, and really yours?*

- ***You cannot discover your own style and voice without putting in the work.*** *It takes a lot of time and practice. For me, this means that I can't wait for inspiration to come find me. I often sit down and grab a few favorite supplies without having the faintest idea of what I'm going to draw and paint, but with the intention to create and learn. My work doesn't have to be good, and I don't even have to finish it. It's the practice and the intention to create that count and that help with developing your own way of doing things and therefore your own style.*

Create the Drawing

1. I read and searched online to gather ideas for period hairstyles and clothing and made little notes and sketches. (I don't have an actual sketchbook; when I have an idea, I write and draw on little pieces of paper.) Here's my initial sketch of the Beast (**A**).

2. I worked on a square area measuring 11.8 × 11.8 inches (30 × 30 cm). My paper was actually bigger, so I drew a line to mark my desired image shape/size, but left the excess so I could use it for the rose locket and other 3D elements (see opposite). Draw a moon (using a plate to achieve a nice circle) and make a simple tree-shaped stencil mask. I drew a tree on one side and then flipped the mask to create a similar tree on the other side. This creates symmetry and balance so the background doesn't distract and the characters can be the focal point (**B**).

3. Add characters: Beauty wearing a beautiful long dress, a cute talking parrot, and a tiny Beast, hidden in the locket. On the excess paper along the side, draw the rose locket, another rose for Beauty's hair, and a few oranges and leaves. At this point I didn't know how many I would need, so I just had fun filling up the remaining space (**C**).

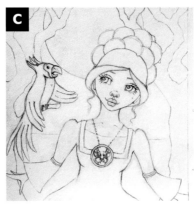

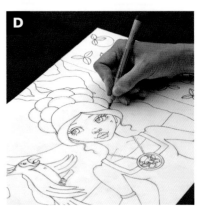

4. As you can see, I'm a messy sketcher, often changing my mind, adjusting lines, and making smudges. I don't like to start my painting with a gray haze that might show up in the end result! So I trace all my lines with a burgundy red waterproof pen. I like working with colored pens because the effect is much softer than when you use a black one. When my line work is dry, I erase the graphite with an eraser (**D**).

5. By tracing my sketch, it loses a bit of spontaneity. To bring back interest, variation, and depth, I add extra weight to lines wherever two from different directions meet, as well as here and there on the longer lines (in the trees, for example) (**E**).

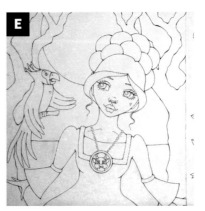

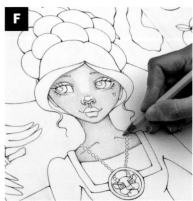

Add Color

1. Use watercolor pencils to color in Beauty's face. Start with a darker skin tone, adding a bit of shading around the face, eyes, under the nose, and bottom lip. Grab a lighter color to fill in the rest of the face, overlapping the colors here and there. Leave the bridge and tip of the nose white (**F**).

2. Dilute the pigment with a water brush. For smooth blending, keep the tip of the brush toward the darkest parts, working from dark to light. Then color in her eyes, her lips, and add a bit of color on her cheeks. Put some color on your paper and then dilute it with your water brush. For extra-bright colors, pick up the color directly from your pencil with your brush. Make sure to let the pencil dry before using it on your paper again to avoid smudging (**G**).

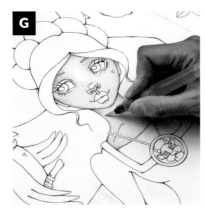

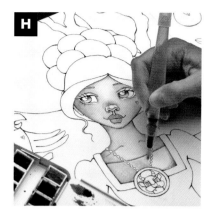

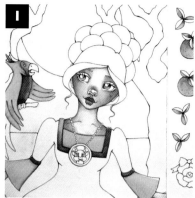

3. I added color to the rest of the painting using watercolor pencils or pan watercolors, often combining the two (**H**).

4. When coloring in, make sure to work with a color in more than one place. When I use orange on the oranges, I make sure to add a bit of that same orange in other places—on Beauty's cheeks, on the trim of her dress, and on the parrot— to help create harmony (**I**).

5. Use a gray-blue for the moon, a very granulating color that helps achieve a moon-like texture. Note that I also used some of this color in the trees to create the bark texture. Because the moon is quite large, switch from a water brush to a regular watercolor brush that can hold a lot of water and paint. Work quickly for the best results (**J**).

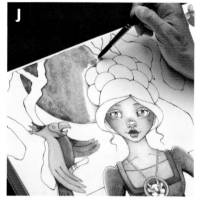

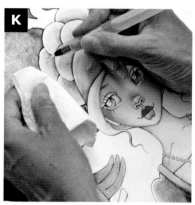

6. When working with watercolor, I try to keep my lightest lights by leaving the paper untouched, but to be honest, that doesn't always work, and I make quite a few mistakes. I try to correct them by wetting the area and blotting it with a paper towel. But some colors really stain, so this won't work. In those cases, a white paint pen on the dried surface will do the trick (**K**)!

7. Watercolor can be an unpredictable medium; I love how it can surprise you with happy mistakes and add interest to the painting. But sometimes these surprises aren't quite what I was going for. I wanted my night sky to be really dark, forming a nice contrast with the moon, the trees, and my characters, but for some reason it turned out blotchy. To remedy this, I switched to watercolor crayons, which in thick layers are slightly opaque. Using a very dark indigo blue, I went over the whole sky and achieved the color I was going for (**L**).

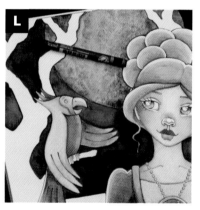

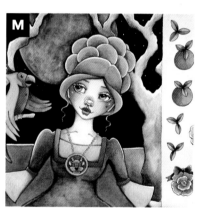

Adjust Colors; Add Details & Final Touches

1. When color has been applied to every area, take a closer look. Is there enough contrast between the background and the main characters? I added a few extra touches of color with water-soluble crayons. Then it's time for a bit of magic. Use a black permanent pen and a white paint pen to add the pupils and a few highlights in the eyes. I love how that makes my characters come to life! With a white pen, add a few more details: freckles on Beauty's nose, highlights on her cheeks, a few sparkly white dots, and highlights on the necklace and trees. Fill the night sky with sparkly stars for a fairy-tale feel (**M**).

2. Cut off the excess strip of paper, cut out the oranges, leaves, and roses, decide on their placement, and glue everything down. To be able to open the locket and show Beauty's heart truth, use a colored brad instead of glue (**N**). When all the collage elements are glued, check one more time to decide if your painting is finished. My most important criterion is whether it makes me happy and smile. And it does! I hope you like this lesson and give it a try! Happy painting!

The Frog Prince

Guest Teacher Danita Art

Meet Danita Art

I've been a fan of Danita's artwork for many years, and I'm a proud owner of one of her amazing art dolls. I'm particularly drawn to the sense of innocence I experience when I take in her breathtaking artworks. I love how she conveys emotion and a world of magic and whimsy in her art. For this lesson, she's working with the story of "The Frog Prince."

THIS IS THE STORY OF A PRINCESS who loved to play with her golden ball at the edge of a pond, until one day the ball rolled and fell into the pond. A frog helps her retrieve the golden ball in return for something. Desperate for her ball, the princess promises "anything" to the frog, being rather appalled later when his request is to come live with her. The story ends with the frog turning into a handsome prince who marries the princess.

Best known through the Grimm Brothers' version (1812), parts of the story date back to Roman times. "The Frog Prince" is the first fairy tale in the Grimms' collection.

My Thought Process

Every artist has a medium they've fallen in love with. Mine is watercolor.

The water from the pond connects directly to the water I use to paint; the story begins close to the water, and if the ball hadn't been lost there, none of it would have happened. Just as with watercolor, the painting wouldn't exist without water, and that's why the emotional connection is so strong.

I incorporated my personal mythology, and I relied on the strong emotions that I evoked from the orange tree and the princess' innocence, as they remind me of myself and they connect deeply to my personal story.

What I Wanted to Bring to the Story

The princess in this story enjoyed playing with her golden ball in the shade of an orange tree, and one of my favorite activities as a child was sitting and playing in the shade of a big orange tree in my parent's front yard. I would sit there and daydream for hours at a time. As a focal point for this illustration, I wanted to recapture this experience of my childhood.

The princess is partly me, and having her play with her favorite toy under the orange tree brings me back to my childhood.

The golden ball represents my hopes and dreams—they're so important for her that she promised anything to get it back. I wanted my painting to focus on the princess and the ball, and less so on the frog, to emphasize the princess' (or my) hopes and dreams.

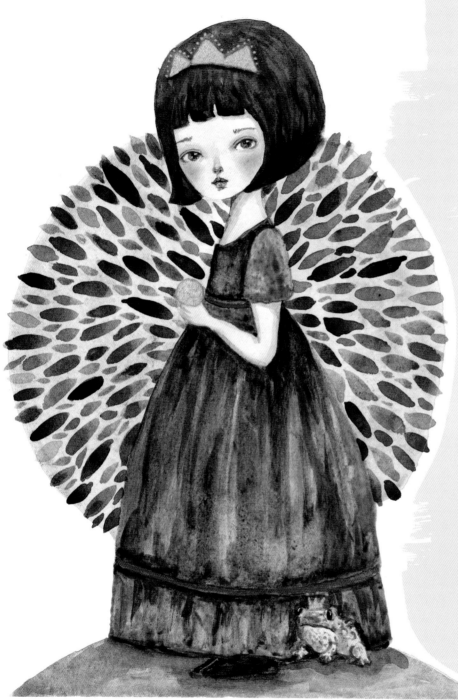

DANITA'S TIPS FOR DEVELOPING YOUR OWN STYLE

- *Practice, practice, and then practice some more.* I cannot emphasize this enough. Only through practice will you find your own personal style, what you like to do, and how to do it.

- *Try as many mediums as you need until you fall in love.* I've used a lot of mediums for my art—acrylics, oils, pastels, pencils, collage, and everything in between—but I always go back to watercolor. Experimenting with different mediums has given me the experience to appreciate what can be done with each. I really recommend you try it.

- *Look for inspiration outside of art.* Inspiration can be found when you least expect it. Whenever I have a dry spell, I get out and look at other things: the birds in the park in front of my house, children's books at the library, my favorite movie, just things I find beautiful, and most of the time they have nothing to do with art. But I feel recharged by doing that. And looking at different things may trigger the spark you were looking for.

- *Study the art you love and then learn about the artist as much as you can—*their techniques, their themes and motivations, and what happened in their life when they created a specific piece. It will give you an insight you weren't expecting, and you'll learn a lot in the process.

Sketch and Draw the Design

1. I rarely start working directly on a painting. Instead, I brainstorm ideas, create a series of sketches on paper, and then choose my favorite (**A**).

2. Once I was happy with my idea, I traced it on watercolor paper using a 2H pencil. Make sure that you use the least amount of pressure while doing this. Watercolor paper is very delicate, and you can dent it easily if you apply too much pressure (**B**).

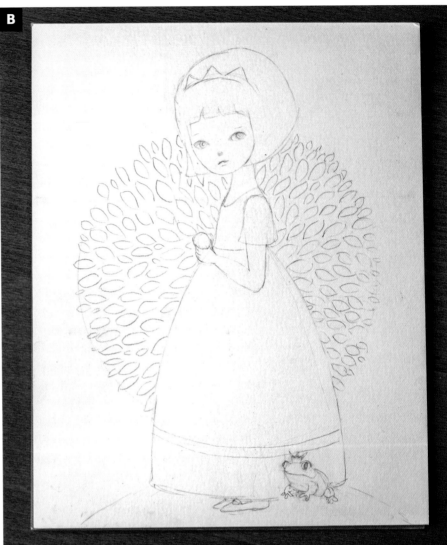

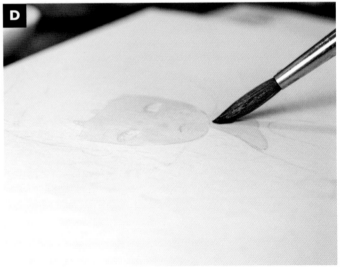

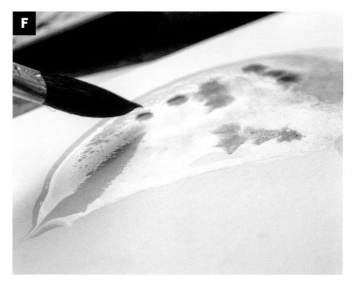

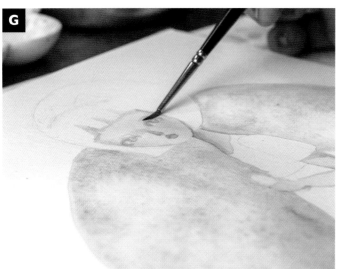

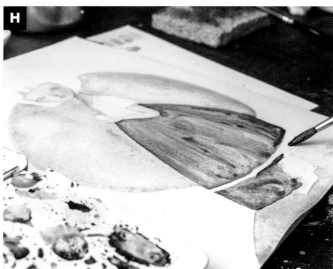

Paint the Design

1. Test skin colors to find your favorite. I started with a reddish-orange tone and diluted it with water until I found one I was happy with. We'll work with layers, so don't start with a dark one. We'll build up deeper colors as we go (**C**).

2. Fill all the skin areas first, using light strokes and basic shading. While still wet, add a little more skin color to the cheeks, elbows, nose, and mouth. Don't worry about the details yet; we're just establishing basic shapes at this stage (**D**).

3. Paint the background with a clean brush and water, defining the shape of the tree that will be the main feature behind our princess. Start adding different green hues using a wet-on-wet technique, and let them mix on the paper while everything is still wet (**E & F**). Then let it dry.

4. Time to paint the face! Use light colors as you layer them over the face. It's best to start slow and layer in several steps rather than use too much paint and have to start over because the face has too much paint and no gradients or nuances built up (**G**).

5. Paint the dress on dry paper. Start applying the paint using long brushstrokes to create the fabric folds. I chose a deep blue. Apply paint little by little so you build up layers and an organic texture (**H**).

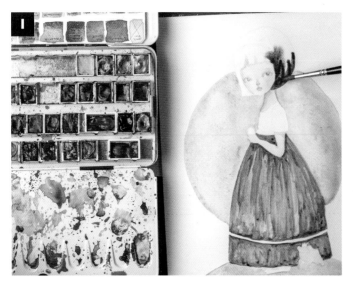

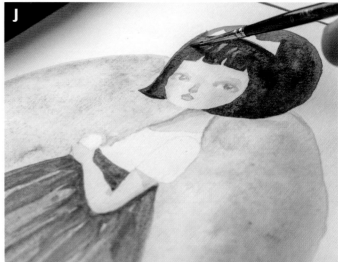

6. As you did for the background, wet the hair areas and then add paint in layers to create a rich texture. Add darker shades to indicate shadows (**I & J**).

7. Remember, we're working in layers, so now it's time to go back to the face and start to shade it using darker colors. Mix your base skin color with darker shades and test on a scrap of the same type of paper you're using for your final piece (**K**). Then add color to the nose, cheeks, and eyes (**L**).

8. Pick deep shades of green for the leaves. Test the colors first, keeping in mind that we'll use the paint almost straight from the tube or pan. To create the leaves, place the tip of the brush and then use sideways pressure to make an imprint of the whole brush shape on the paper. Lift it using the same movement. It will leave an oval shape that looks just like a leaf (**M**). Repeat with different shades until you cover the tree (**N**).

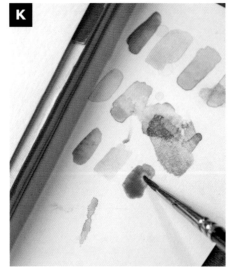

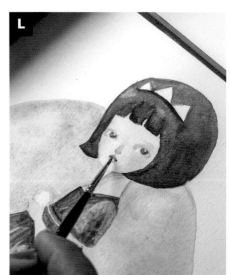

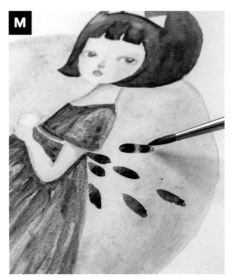

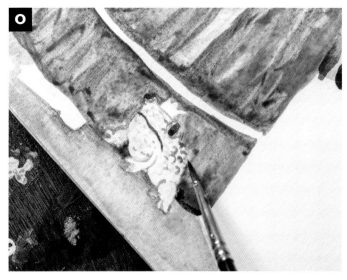

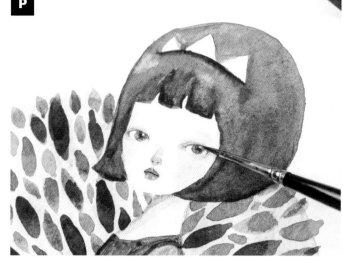

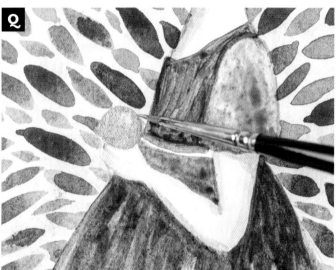

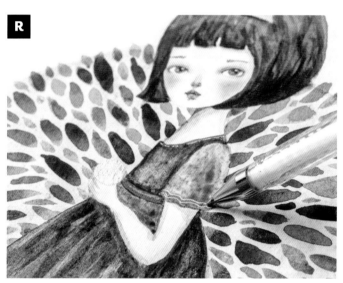

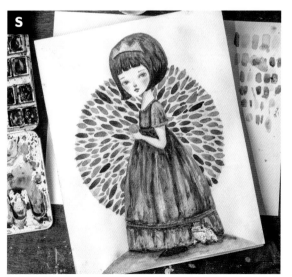

9. It's frog time! There's a lot of green in my original painting, so I used a pink tone for the frog. Test different dilution and saturation levels of the same color to paint it (**O**).

10. Keep adding color and details to the face, eyes, and dress. We're going for a soft, delicate look, so use light layers of pinks on the cheeks (**P**).

Add Finishing Touches

1. Use a golden color for the crown, the gold ball, and the frog. I love this step—the gold paint is magical, and I love how it swirls and dances as it dries (**Q**).

2. Use a pen to add white details to the dress and anywhere you'd like to see highlights. I also added them to the eyes and crown (**R**).

3. Add the final shading details to the tree, dress, and face, and you're ready to enjoy your finished piece (**S**)!

The Reluctant Dragon

"**The Reluctant Dragon**" is a story by Kenneth Grahame (1859–1932), about a boy who discovers that a poetry-loving dragon lives in the Downs behind his house. The boy and the dragon become friends, but the people in the village discover the dragon and send a knight, St. George, to get rid of him. The boy convinces the knight that the dragon is friendly and harmless, so the knight and dragon decide not to fight. To appease the village people, however, they stage a fake fight. The knight doesn't kill the dragon but pretends to wound him. The knight then explains to the village people that the dragon isn't dangerous, and the village people end up accepting him.

My Thought Process

I only discovered this story when I was writing this book and was delighted to find it. It was so refreshingly different from many of the other fairy tales written around the same time. There's much less of a focus on "good vs. evil" and moralistic messages. Instead, the character usually deemed as evil or dangerous (the dragon) turns out not to be and actually loves to read poetry. I was also happy to read that all characters ended up open-minded enough to be convinced that the dragon wasn't dangerous. This truly seemed a story of "happily ever after" for *all* the characters, which made me smile.

What I Wanted to Bring to the Story

I didn't want to bring much else to the story because it disarmed and delighted me in the way it was presented. I decided to create a painting focused on a dragon holding a book, and I wanted to put his friend, the little boy, on a swing nearby, set within a nature scene. The boy isn't described as being on a swing in the story, but I did so to emphasize the story's playfulness and the relaxed way the dragon and boy got on with each other.

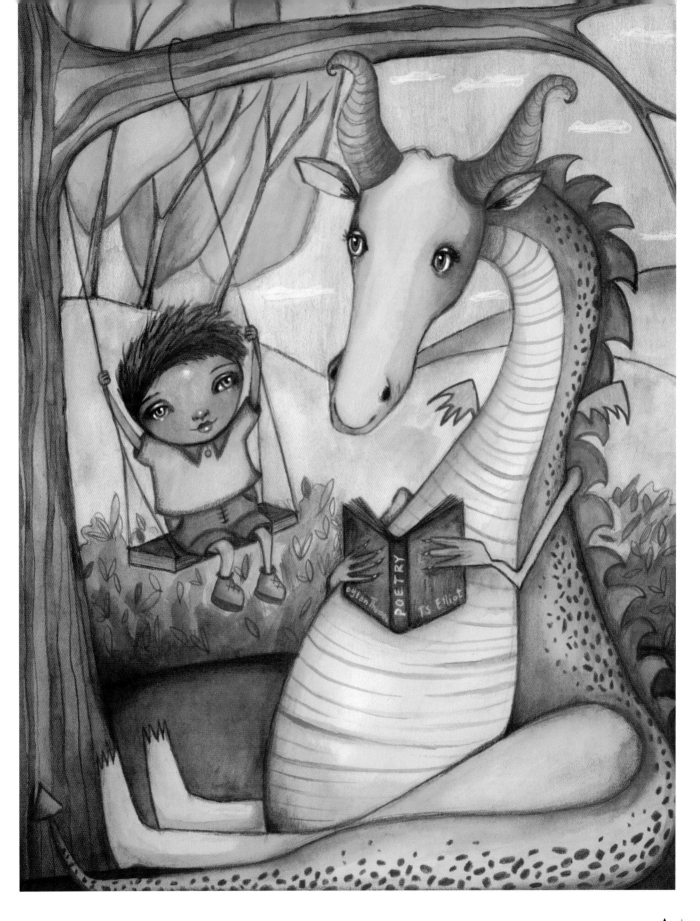

Draw the Design

Draw/sketch the design of the Reluctant Dragon painting (**A & B**).

Paint the Dragon & the Boy

1. Work mostly with greens and blues, using Tombow markers, watercolor paints, and crayons. Start with a first wash of watercolor paint in lime green on the dragon (**C & D**).

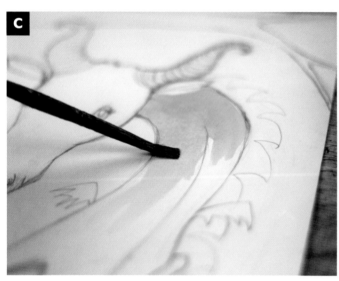

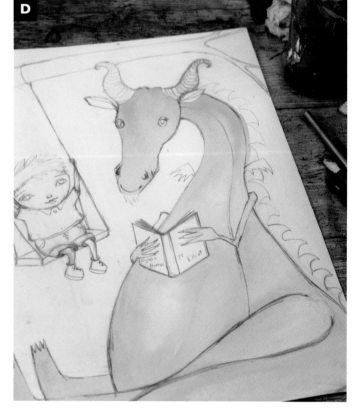

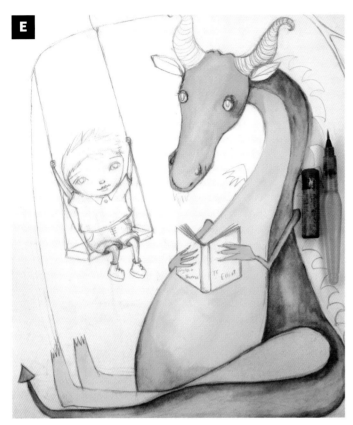

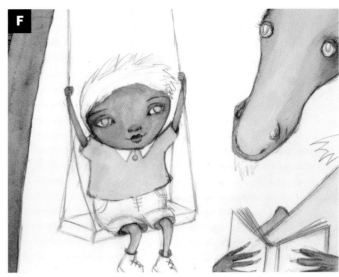

2. Use a blue/turquoise crayon to add darker areas to the dragon (E).

3. Add first layers of paint to the tree in the foreground and the boy's face and clothing (F).

4. Continue to deepen the shading on the dragon and the boy's clothes. I deliberately used similar colors for both these elements so the overall color scheme made sense (G).

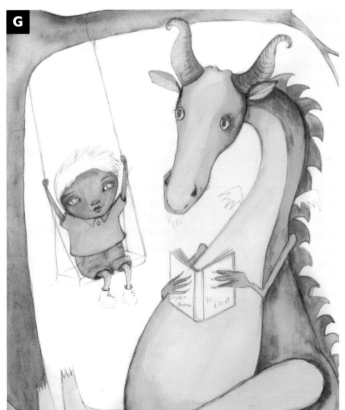

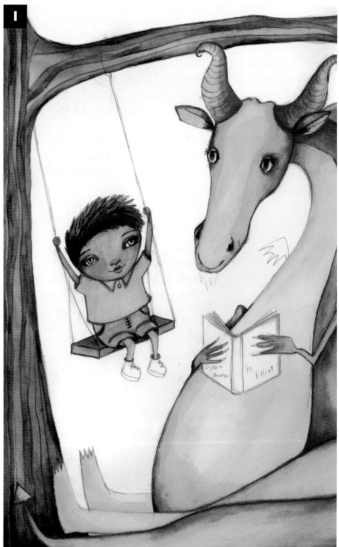

5. Deepen the detail and shading on the tree and add some color and detail to the boy's hair and clothing (**H & I**).

6. Add lines to the dragon's tummy and "spots" to his back to make him "lizard-like" (**J & K**).

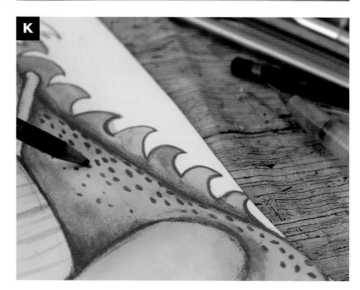

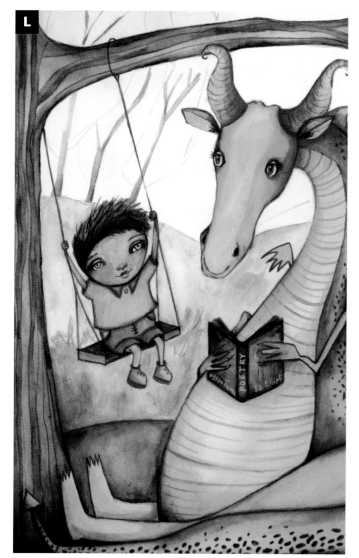

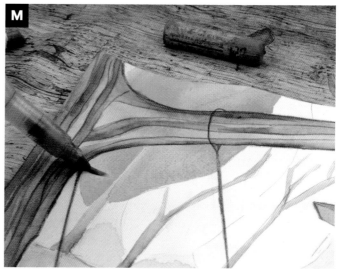

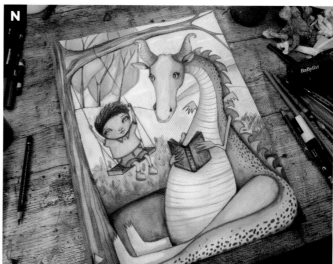

MAKE IT MEANINGFUL

While the real T. S. Eliot's name is spelled with only one l, my child's name has two. Elliot with two ls on the dragon's book is in my son's honor. This makes the painting especially meaningful to me and is a fun way to enjoy a little in-joke with my family. You can title the book in your painting any way you like, so it's meaningful to you!

Create the Background

1. Draw some background elements. To give the impression that they're on the Downs or in the middle of some beautiful hills, I drew and then painted bushes nearby and hills and the branches of trees in the distance (**L**).

2. Add light washes of paint to the trees, sky, and hills (**M & N**).

3. The dragon is holding a book entitled *Poetry*, and I put the names of poets Dylan Thomas and T. S. Elliot on the cover as a little tribute to my children (who are named Dylan and Elliot after those famous poets) (**O**).

Guest Teachers

Kara Bullock

Kara is an artist who lives in Southern California with her supportive husband, Jeff, and their three creative and inspiring children, Charlotte, Claire, and Brady. Kara has more than twenty years of experience in teaching and curriculum development, first as an elementary school teacher, then later taught online college-level education courses. In 2018, Kara began working full-time as an artist, art instructor, and mentor, where she quickly transferred her experience as an online instructor to teaching art to students all over the world.

Working in a somewhat impressionist style, Kara has always been drawn to creating portraits, probably because of her love for people, and wants her audience to be drawn to what's happening in the life of the individual at the moment that they were painted.

Website: karabullockart.com

Lucy Chen

Lucy is an artist based in Sydney, Australia. She is a single mother of two mischievous kids and practices a vegan lifestyle. Contrary to how she was raised, as an atheist by her Communist father and grandparents, her art is all about awakening intuition and reconnecting to the beauty and magic in life. She hopes her artwork will take you on a magical journey with her.

Website: lucychenfineart.com

Danita

Idania Salcido, also known as Danita Art, is an artist for whom creation is not a choice, but an imperative from the inscrutable exhortations of her soul. She says: "*I must create to feel alive, and to let my mind flow in peace, exploring every corner of the worlds I create.*" Her artwork is inspired by her personal experiences and memories. Her emotions shape the things she creates. Danita works in mixed media and watercolor and hand-sculpts art dolls to express her inner world. She paints the female form, concentrating on expressing feelings through colors and shapes while creating a dreamy, surreal, and whimsical atmosphere.

Website: danitaart.com

Andrea Gomoll

Andrea is a mixed-media artist and illustrator from Falkensee, Germany, where she lives with her husband, Thomas, and three crazy cats. Watercolor is her medium of choice, but in a fresh, less traditional way. She loves to combine it with inks, markers, collage, and lots of texture for a unique mixed-media look. She has a whimsical style; she loves colorful illustrations and playful big-eyed-girl portraits. She loves to inspire others with her creative creations and to enable others to live a creative life by teaching art classes online.

Website: andrea-gomoll.de

Annie Hamman

Annie is a mixed-media artist and teacher from South Africa, specializing in portraiture, incorporated into what she calls "Soulful Story Art." There are always many elements surrounding her faces and figures: objects, landscapes, birds, trees, haloes, wings. Her art is most often painted with a spiritual undertone and in a semi-surreal way. She assembles her compositions from numerous carefully selected references to portray a very symbolic narrative, full of emotion and meaning.

Website: anniehamman.com

Mariëlle Stolp

Mariëlle Stolp is a mixed-media and journal artist. She loves to create dreamy, boho-style or fairy-tale girls in her art journals. Magic, love, nature, storytelling, and her daughters inspire her whimsical work. She enjoys working with water-based mediums such as watercolor, inks, and water-soluble crayons and colored pencils. Mariëlle is based in the Hague, in the Netherlands, and lives with her three beautiful, bright daughters, her supportive husband, and two naughty cats.

Website: mariellestolp.wordpress.com

Effy Wild

Effy Wild has been using art journaling as a way to meet herself on the page since 2009. She teaches online, runs Journal52 (journal52.com), #MiniMoleyDaily (facebook.com/groups/minimoleydaily), and offers full-length and mini (some free) workshops in her teaching network at learn.effybird.com. She also blogs at effywild.com. Effy considers herself a journal artist, and her emphasis is always on process over finished product. She lives in Ontario with her lovely dog, Sookie, and works from her home studio.

Website: effywild.com

Micki Wilde

As a self-confessed hermit, Micki experiences her work as a source of escape from the man-made world outside her door. Her paintings are a safe haven where fantastical dreams are born and wild, magical animals are free to roam. Her work is approached in a light-hearted manner with the hope to charm and endear its characters to the onlooker and draw them into her wild and wondrous world.

Micki's painting process is a fusion of preplanned and intuitive work, with the main aim to create a thought-provoking visual tale honoring nature and a connection to the land. She works with a range of mediums but typically uses paint, pencils, and a whole lot of love to create layers and help these stories unfold.

Website: thesecrethermit.blogspot.com

Resources

- You can access Ever After meditations and some free videos online by going to willowing.org, then navigate to the Ever After tab, add the Ever After Book Resources product to your cart, then use the coupon EABOOKLOVE to get 100% off the product. If you have trouble, please email us at hello@willowing.org.
- To support your mindfulness and self-awareness practice I recommend the app Insight Timer which has numerous free meditations available.
- I've loved watching the TV show *Once Upon a Time* in which they have explored a very different take on the traditional fairy tales.

- A great and comprehensive book of traditional fairy tales is *Grimm's Complete Fairy Tales* by Jacob Grimm, Wilhelm Grimm, et al.
- The Society of Storytelling: sfs.org.uk
- Tam's online places:
 www.youtube.com/willowing
 www.pinterest.com/willowing
 www.facebook.com/groups/willowing.friends
 www.instagram.com/willowing

Acknowledgments

WRITING A BOOK IS A BIT LIKE BIRTHING A BABY! It takes a lot of effort, sleepless nights, and wonderful people (midwives) to make it happen! My deep gratitude goes out to the following amazing people:

♥ **Andy Mason,** for being "my sun" and "my moon," my friend and my therapist, the keeper of the Tam heart, and my happily ever after.

♥ To my children, **Dylan** and **Elliot,** who know how to invoke magic through their wild, playful storytelling and imagination! They inspire me every day to be my best self and to stay in touch with the mystery within.

♥ **Gracie Howle** (also known as d-dog, my potato friend, and glitter monkey), for getting me, for being there for me, for listening to me offload the joys and sorrows of my soul, and for being unconditionally accepting of my quirks and odd ways.

♥ **Maddie Turner** (also known as Maddie fire fingers), for being a rock for the customers and students, for listening to me when I grapple with the stuff of life with such loving care and empathy, and for being always at the ready to help and support.

♥ I also want to thank all **"Ever After" Online Students,** who have deepened their voices and art styles through the online courses by working hard and digging deep into their own stories. Their art, authenticity, sharing, and support of each other touches and moves me every day.

♥ Deep gratitude goes out to all past and present **"Ever After" Teachers,** who have made "Ever After" such a wonderfully varied, interesting, and inspiring experience. Thank you for sharing your knowledge, techniques, and insights with us over the years.

♥ A huge thank you goes out to the **contributing artists** of this book: Effy Wild, Andrea Gomoll, Lucy Chen, Danita, Kara Bullock, Annie Hamman, and Mariëlle Stolp. You made this book extra special!

♥ **Joy Aquilino** at Quarry, for working with me on a second book and responding to me with such patience and grace through the stressful times! Thank you for your support and hard work on this book!

♥ **The great storytellers of the world,** for writing their stories and capturing the wide scope of what it means to be human and alive so that we may use them to deepen our understanding of our own humanity and lived experiences.

About the Author

TAMARA LAPORTE ("willowing") is a creative catalyst of thousands of beautiful people. She is a celebrated mixed-media artist and art teacher who has been running her own creative business since 2008.

Her work can be described as "mixed-media folk art" with a focus on "magical realism." It ranges from whimsical children's illustrations to a more stylized fantasy art. Love, mystery, innocence, hope, spirituality, kindness, and self-connection inspires her art work. Symbolism and layering play a big part in her work. Her paintings often contain healing themes, uplifting messages, and inspirational poetry.

Tam believes that the act of creating art can be a gateway into healing and personal growth—often, her art classes contain an element of self-development as well as learning art techniques. She is deeply devoted to helping people get in touch with their creative fire and would love to help *you*, too, get in touch with the artist in you!

Tam is the inventor and creator of two major online e-courses: "Life Book" (which is a year-long mixed-media art course with a focus on personal development) and "Ever After" (which, like this book, focuses on developing one's own creative style). Collectively, more than 23,000 students have joined her courses!

Deeply passionate and caring for the well-being of the world and its people, Tam works tirelessly to bring uplifting, nourishing, creative, and empowering content to her amazing tribe of more than 43,000 souls.

Her work and articles have been published in several art magazines and books and she's been interviewed for several online radio stations and summits. She runs a variety of popular art classes through her online art school (www.willowing.org), which has more than 42,000 members and grows by about 150 to 200 enthusiasts each month!

Tam lives and works in the South of England with her handsome husband, Andy, two magical boys, Dylan and Elliot, four guinea pigs, and Gizmo, the crazy dog. Her two awesome team members in the studio are the glitter-filled Gracie Howle and the wildly mesmeric Maddie Turner.

Index